The Campus History Series

PERKINS SCHOOL FOR THE BLIND

The Campus History Series

PERKINS SCHOOL FOR THE BLIND

KIMBERLY FRENCH
FOR PERKINS SCHOOL FOR THE BLIND

ARCADIA

First published 2004

Published by Arcadia Publishing,
Charleston SC, Chicago IL, Portsmouth NH, San Francisco CA

Printed in Great Britain

Library of Congress Catalog Card Number: 2004103265

For all general information, contact Arcadia Publishing:
Telephone 843-853-2070
Fax 843-853-0044
E-mail sales@arcadiapublishing.com
For customer service and orders:
Toll-free 1-888-313-2665

Visit us on the Internet at www.arcadiapublishing.com

*Perkins School for the Blind gratefully acknowledges
the generosity of board chairman C. Richard Carlson and
Deborah Carlson, whose gift has made this book possible.*

CONTENTS

ACKNOWLEDGMENTS

I am deeply grateful to the many people who assisted me in the preparation of this history. Most of all I want to thank Jan Seymour-Ford, Perkins research librarian and chair of the Perkins History Book Committee, who deserves a large share of credit for this book. Always a complete pleasure to work with, she researched the archival photographs, wrote the captions, provided me with packets of historical information that I looked forward to finding in my mailbox almost every day, and oversaw every aspect of putting the book together.

A huge thank-you as well goes to Ken Stuckey, former research librarian and a wealth of knowledge about Perkins, who was always instantly available by e-mail, taking time away from his retirement in Sweden to get to the bottom of any sort of question, big or little.

I am also thankful to Perkins History Book Committee members Robert Guthrie, who could be counted on to supply the right word at the right time and helped with recent history; and Betsy McGinnity, who was that rare source who knew how to zero in on just the facts I needed, as well as to provide the perspective that brought the information to life.

I am indebted to the Perkins staff and officers who shared their time and expertise: C. Richard Carlson, chairman of the Perkins School Board of Trustees; Mike Cataruzolo, supervisor of Volunteer Services, for a delightful tour; Kim Charlson, director of Perkins Braille & Talking Book Library, for careful reading of the text; Michael Collins, director of the Hilton/Perkins Program; Cynthia Essex, supervisor of the Secondary Program, for clarification of many details along the way; Kevin Lessard, past director, for great storytelling; Barbara Mason, supervisor of the Deafblind Program; Larry Melander, supervisor of the Lower School; Tom Miller, supervisor of Preschool Services; Leon Murphy, Howe Press Brailler technician; H. Gilman Nichols, former board member and former treasurer; Marianne Riggio, national educational consultant for the Hilton/Perkins Program; Steven Rothstein, president; and Jan Spitz, director of Development/Public Relations.

I am grateful for information provided by Donald Hubbs, head of the Conrad N. Hilton Foundation; Bernadette Kappen, past president of Council of Schools for the Blind and director of Overbrook School for the Blind in Pennsylvania; and Marje Kaiser, president of the Council of Schools for the Blind and superintendent of the South Dakota School for the Blind and Visually Impaired.

I am also indebted to histories and papers written by Michael Collins, Anna Fish Gardner, William T. Heisler, Robert Irwin, Marjorie Lagemann Snodgrass, Ken Stuckey, and Edward Waterhouse.

Many thanks to my personal group of readers for their invaluable feedback: Cynthia Benard, Kent French, and Paul Hostovsky; and most of all, two of my dearest friends, both excellent writers and readers, Jan Gardner and Michael Rozyne.

INTRODUCTION

The idea that children who are blind are entitled to an education seemed to spring fully formed onto the 19th-century American landscape. In one year, 1832, three schools for the blind opened their doors—in Boston, New York City, and Philadelphia. The New England Asylum for the Blind, now the Perkins School for the Blind, was the first to be incorporated, in 1829.

A couple of circumstances of Perkins's birth continue to shape the school. First, the school was created in the cultural milieu of Unitarian Boston, with its firebrand social reformers taking on the blights of poverty, illness, ignorance, and slavery. This idealism was embraced by Samuel Gridley Howe, the school's director for its first 40 years. Although Howe took care that no one could accuse him of running a religious school, his deep beliefs in service to others and improvement of the human condition have always guided the school's philosophy.

Today, Perkins continues to expand on its founders' idea that children who are blind or deafblind deserve an education and can achieve self-sufficiency. Now as then, Perkins seeks to teach the whole student—providing academics, vocational skills, daily living skills, and social and recreational opportunities. For 175 years, the school has successively widened the circle to include people who have multiple disabilities, very young children with disabilities and their families, people who lose their vision later in life, and people with disabilities in developing countries.

Another circumstance of birth that has played a providential role is Perkins's incorporation as a quasi-public-private institution. To help the school get started, the state appropriated $6,000 a year for 20 students' tuition, and the governor appointed—and still does—some of the trustees. To sustain itself, however, the school has always had to seek private funding. That fact, although a challenge, has given Perkins the flexibility to launch new initiatives, while public-sector agencies and institutions in other states must cut or limit programs despite needs, especially in recent times.

One example is Perkins's decision to spend almost half of the Howe Press endowment to manufacture Perkins Braillers in the 1950s, a risk that would have been difficult to take under another financial structure. In 1970, the school built two buildings to accommodate the large number of children with congenital deafblindness from the rubella epidemic. The program ran at a large deficit for several years before government funds became available to pay a portion of the costs to educate those students. In the 1980s, Perkins educators saw that their expertise could help new parents of infants and toddlers who are blind, but no grant money could be found. Perkins trustees decided to tap the school's own funds to provide those services—a program that now serves 450 babies in the state every year.

Because most children with blindness or vision impairments attend public schools in their communities, Perkins now has only about 200 students in its residential school, down from its peak enrollment of over 300. Yet worldwide the school touches 40,000

lives each year by enrolling day students who live with their families; through the Perkins Braille & Talking Book Library, which circulates by mail throughout New England; through its outreach services to public school students and elderly clients, who make up the fastest-growing category of people who are blind; through its Preschool Services; through teacher training; by supporting schools, programs, and teachers in developing countries; and by helping to establish and promote organizations that support the very best advocates for children who are blind—their families.

Perkins's long and proud history teems with idealistic, colorful, and innovative personalities. Its first director, the dashing and adventuresome Samuel Gridley Howe, also did turns in his life as a freedom fighter in Greece and Poland, a leader in wartime relief, a pioneer in education for the developmentally disabled, an abolitionist, a politician, and a social reformer—all in addition to teaching the first deafblind person to learn language, Laura Bridgman.

His successor—and son-in-law—Michael Anagnos founded the country's first kindergarten for the blind and used his considerable gift for fund-raising to set the school on a firm foundation, physically and financially.

At just 21, with no college education, Perkins graduate Annie Sullivan instinctively developed techniques to break through to her young charge, Helen Keller, that are still fundamental to deafblind education today. For five years, Sullivan and Keller thrived at the school, where Keller for the first time found peers who could communicate with her.

David Abraham, a self-taught mechanical wizard from Liverpool, England, happened to knock on the school's door looking for work during the Great Depression—and turned out to have just what Perkins was looking for: the patience and perfectionism required to design a new standard in a writing machine for the blind, the Perkins Brailler, which is still widely used today.

The philanthropy of Conrad Hilton, the international hotelier and a contemporary and admirer of Helen Keller, has enabled the school to spread its expertise and services to people with disabilities in more than 50 developing countries.

All of these pioneers and idealists, along with the many generations of hardworking students and dedicated staff who are the school's lifeblood, have made the school the educational leader it is today. Perkins School for the Blind is committed to carrying their legacy into the 21st century.

One

THE FOUNDERS

John Dix Fisher had long known his life's work would be in medicine. Just as he was about to start his practice in Boston in 1826, however, he felt another calling that he could not ignore.

In early-19th-century America, the common view was that people who were blind—or had any disability—could never be fully contributing members of society. The most compassionate course, some held, was to keep them from learning so they would not know what they were missing.

Fisher had done postgraduate study under some of the most famous doctors in Paris. There, he had visited the world's first school for children who were blind, L'Institution Nationale des Jeunes Aveugles, founded by Valentin Haüy in 1784. Fisher was much impressed. Students were taught to read raised-type books and to write. They learned mathematics, geography, languages, music, and manual arts. Fisher resolved to bring education for children who were blind to his own country.

The spiritual and intellectual movement called the New England Renaissance was in full blaze, and Boston was its center. Reformers, led by Boston's Unitarians, were taking up the causes of people with disabilities and disadvantages: William Ellery Channing for the poor, Thomas Parker for child factory workers, William Lloyd Garrison for the abolition of slavery, Horace Mann for universal free education, and a bit later, Dorothea Dix for the mentally ill and incarcerated. Among this company, Fisher called for a school for the blind.

For three years, he tried to inspire well-placed family friends with his idea. One icy February day in 1829, he called a meeting at the Exchange Coffee House. The group voted to incorporate the New England Asylum for the Blind. Within weeks, the Massachusetts legislature unanimously approved the incorporation and provided $6,000, without knowing how many blind children lived in the state or how the school would operate. Thirty-nine prominent Bostonians were named incorporators, including Thomas Handasyd Perkins, a wealthy shipping merchant who was losing his eyesight; William Prescott, a historian who was blind; Horace Mann, Fisher's college friend; and members of the Lowell and Thorndike families, whose descendants have continued to serve Perkins over the years.

With no building, director, teachers, or students, the work of establishing the school crept along. Fisher asked Thomas Gallaudet, who had founded the first school for the deaf in 1816, in Hartford, Connecticut, to direct the new school. Gallaudet, and a string of other candidates, all turned him down.

In the summer of 1831, Fisher spent a day riding and talking about his dilemma with his friend from Brown University and Harvard Medical School, Samuel Gridley Howe. The 29-year-old Howe, recently back from seven years as a soldier and surgeon in the Greek War of Independence, had been adrift, searching for a new cause. He volunteered for the job.

To prepare, Howe spent most of a year visiting European schools for the blind. He "found in all much to admire and to copy, but much also to avoid," he reported. His observations became a foundation for much of the current thinking and ideals of special education.

Students who are blind are best taught skills to support themselves, rather than just for show or institutional life, Howe theorized. He disapproved of overprotective teachers and family members always stepping in to help. He praised schools that taught useful trades, such as mattress making and rug weaving. He criticized one school that required a wide range of subjects, regardless of individual aptitude, and others that did not teach reading and had no books. He objected to public displays of students, which "redound rather to the glory of the State than the good of the pupils"—although he later found such displays were necessary to secure funding.

He also faulted the European schools for not correcting unconscious mannerisms common among people who were blind—such as rocking, eye poking, and light gazing—by "accustoming them to society," just as seeing children learn proper social conduct. He found the tactile maps, slates, and books used in Europe clumsy, poorly engineered, and too expensive to produce in sufficient quantity.

He was delighted to see students of the Paris school chasing, playing ball, and excitedly laughing and shrieking in a park, observing that "they know every tree and shrub." He resolved that daily outdoor exercise would be mandatory at his school.

In short, Howe believed the task of educators was first to solve the practical problems of blindness—such as books and safe mobility—and then to provide children who were blind with the same opportunities, experiences, and hopes as other children. He was ready to begin.

Howe brought from Europe two teachers who were blind, Paris's Emile Trencheri for academics and Edinburgh's John Pringle for mechanical trades. For a building, Howe took over most of his father's house on Pleasant Street in Boston. Learning of a family with five children who were blind, Howe and Fisher rode to Andover and persuaded the parents to allow the two eldest, Abigail and Sophia Carter, ages six and eight, to become the school's first students, in July 1832.

It took the passions and talents of two very different men to start the school. Friends described the clean-shaven, bespectacled Fisher as gentle, kind, modest, precise, sincere, and refined. He became known for writing a seminal text on smallpox, pioneering the use of anesthesia in childbirth, and expanding the use of auscultation (listening to organs) to diagnose more than chest diseases. He was always available to the school, however, serving as its doctor and taking over during Howe's lengthy absences.

Howe cut an entirely different figure. He was tall and strikingly handsome, with jet-black hair and beard and piercing blue eyes. He traveled Boston's streets astride a crimson-blanketed black stallion. He was ambitious and idealistic, as well as resourceful and hardworking, with no care for luxury. For good or ill, he was always ready for an argument or new adventure. Starting a school for children who had never before been allowed to get an education proved to be the challenge he was looking for.

JOHN DIX FISHER, PRINCIPAL FOUNDER OF PERKINS SCHOOL FOR THE BLIND. In the 1820s, Fisher visited L'Institution Nationale des Jeunes Aveugles (the National Institute for Blind Youth) in Paris, the world's first school for students who are blind. For several years, he worked to found a similar school in the United States, and on March 2, 1829, the Commonwealth of Massachusetts granted a charter for the new school.

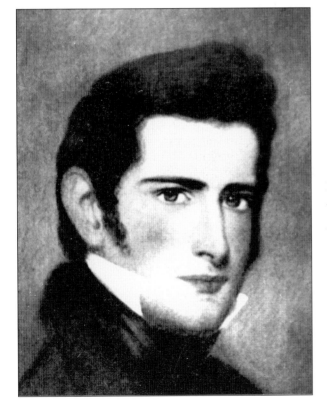

SAMUEL GRIDLEY HOWE, PERKINS'S FIRST DIRECTOR, 1831–1876. After two years of searching for a director, Fisher and two trustees were walking down Boston's Boylston Street and came across Howe, Fisher's college friend. "Here is Howe!" Fisher exclaimed. "The very man we've been looking for!" This Perkins lore is surely an apocryphal rendering by Howe's adoring family. Howe's own letters describe a day spent with his old friend, when he volunteered for the job.

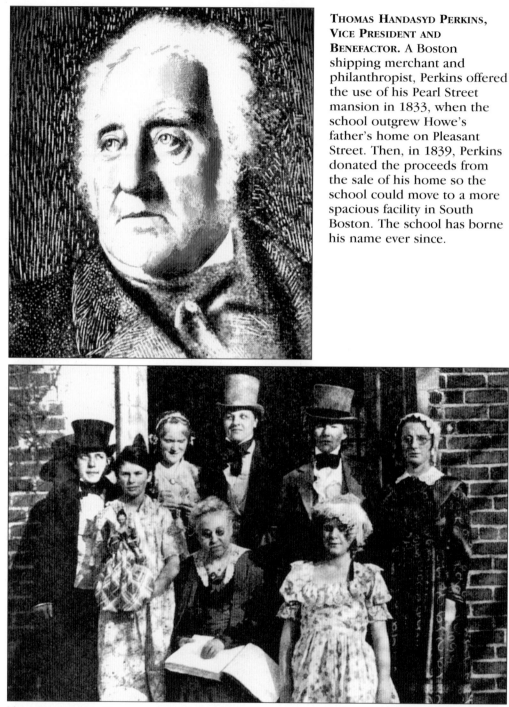

THOMAS HANDASYD PERKINS, VICE PRESIDENT AND BENEFACTOR. A Boston shipping merchant and philanthropist, Perkins offered the use of his Pearl Street mansion in 1833, when the school outgrew Howe's father's home on Pleasant Street. Then, in 1839, Perkins donated the proceeds from the sale of his home so the school could move to a more spacious facility in South Boston. The school has borne his name ever since.

THE CENTENNIAL CELEBRATION. For the 1932 commemoration, students reenacted the founding of Perkins School for the Blind. Here, the play's performers, all girls from Fisher Cottage, pose in their costumes in a doorway of the Howe Building. The self-assured and dashing figure (second from the right) is undoubtedly portraying the handsome Samuel Gridley Howe.

Two

THE HOWE YEARS

Samuel Gridley Howe's love of adventure and ideas—along with his ambition to make his mark on the world—shaped the whole of his life. Just as he had rushed into the struggles for Greek and Polish independence as a young man, he threw himself into creating an American school for the blind.

The year the school opened, 1832, Howe taught six students in his father's house. He had only three raised-type English books brought from Europe. So he devised his own materials—texts, maps, and diagrams—using pasteboard, gummed twine, and pins.

By January, the school was in debt. Although Howe had criticized public demonstrations of blind students, he realized they were necessary. Showing New England state legislators the students' achievements brought more funds—and more students. On Saturdays, the school was opened to the public. Pupils read aloud, demonstrated math and geography skills, and performed music. Howe's later travels with students helped persuade states including Ohio, Virginia, and Kentucky to start their own schools for the blind.

By the first spring, the school needed more space. Trustee Thomas Handasyd Perkins offered to donate his Pearl Street mansion, provided the school could raise $50,000 in a month. Groups of women in Boston and Salem sold their artwork and crafts at competing charity bazaars, the grandest at Faneuil Hall. More than enough money was quickly raised.

In just six years, the Perkins mansion was bursting with more than 60 students. In 1839, the school bought the Mount Washington House hotel in South Boston for $20,000. There, the school, renamed the Perkins Institute, operated for the next 75 years.

Howe dreamed that, through education, people who were blind would readily find acceptance in the work force. That dream is still a challenge today. In 1837, he reluctantly opened a workshop for adults who were blind to make baskets, mattresses, needlecraft, brushes, and other products, sold through the school. It operated in South Boston, often at a financial loss, until 1952.

Challenging as starting a new school was, Howe was constantly on the lookout for a way to break new ground. In 1837, he found it in a girl named Laura Bridgman, who was deafblind. Her education was among his greatest accomplishments.

At the time, many thought it unlikely that people who were deafblind could be taught language or educated at all. There are almost no records of deafblindness before the 18th century and only a couple of previous attempts at teaching communication.

The survivor of a scarlet fever epidemic that had killed two older siblings, Laura was left with only the sense of touch intact. On hearing of the seven-year-old girl who was deafblind, but otherwise healthy, Howe traveled to the Bridgman farm in Hanover, New Hampshire, and persuaded Laura's parents to bring her to Perkins.

Laura had developed some signs to communicate at home, but Howe believed teaching her a verbal language was superior for mental growth. Perkins printers prepared raised-type labels for numerous familiar objects—fork, spoon, key, book. Howe first presented Laura with the items and their labels. Soon, she could match them. Then, Howe gave her individual letters, which she learned to arrange in words. Yet he could tell her progress was all rote memory.

After two months, the significance of language dawned on Laura. "[H]er intellect began to work . . . and at once her countenance lighted up with a human expression. . . . [I]t was an immortal spirit, eagerly seizing on a new link of union with other spirits!" Howe wrote.

The next month, Lydia Drew, who took over most of Laura's lessons, taught her to fingerspell, using a hand shape to represent each letter. A year later, Laura learned to write with a writing board and grooved paper, as other Perkins students were taught. Laura's thirst to learn words, and her ceaseless demands to know the whys and hows of her world, seemed insatiable. In time, she mastered complex English structure and rarely made spelling or grammatical mistakes. Throughout her life, she corresponded constantly with friends and family.

Within three years, Laura Bridgman and Samuel Gridley Howe were world famous. In his 1842 *American Notes,* Charles Dickens was largely critical of the country but praised Boston and his visit to Perkins. Dickens commended Howe's "Noble Usefulness" and called Laura "this gentle, tender, guileless, grateful-hearted being," remarking that "her face was radiant with intelligence and pleasure."

Howe repeated his methods with other students who were deafblind—Lucy Reed, Oliver Caswell, and Almira Alden. No student matched Laura's intellect and accomplishments, however, until Helen Keller. Laura, who was never comfortable again at her family home or out in the world, lived at Perkins the rest of her life, writing, fund-raising, teaching sewing, and selling her needlework.

Howe headed the school till his death in 1876. He felt a constant restlessness, however, to be at the center of the action, which often took him away from Perkins. He served on the Boston School Committee; ran for Congress; cofounded a forerunner of the American Red Cross; and took leadership roles in the prison-reform and abolition movements. In 1846, he opened a wing at Perkins for 10 children with developmental disabilities, proving they could advance in language and behavior through better care and teaching. In 1856, he founded the first school for the developmentally disabled, which became the Fernald School, in Waltham.

Some modern critics have judged Howe harshly. His devotion to Boston Line Type contributed to the delay in the U.S. adoption of braille, a much easier alphabet for people who are blind. His opposition to sign language has vilified him—along with Alexander Graham Bell and Horace Mann—in the Deaf community. That he lacked humility and sensitivity to others' feelings is well documented.

Yet his contributions to blind and deafblind education, to better conditions for the developmentally disabled, and to the great political and reform movements of his time seem almost too great for one lifetime. He left an enormous body of pedagogical writings. He joined Mann's call for free education for all, including those with disabilities. He foresaw the debates over institutionalization and inclusion that are still argued today, holding that "we are all one, they [people with disabilities] are of us, our brothers, our sisters." Whatever Howe's flaws, his place of significance, not only in Perkins's history but also in American and intellectual history, was well earned.

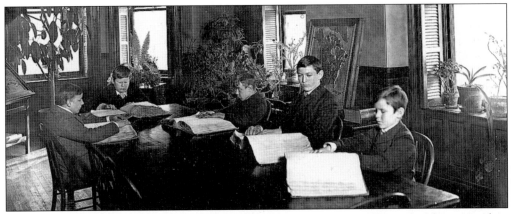

A Kindergarten Reading Class, 1904. These students are studying books printed in Boston Line Type, a system of raised Roman alphabet characters designed by Samuel Gridley Howe. Dismayed by the lack of books for students who were blind, Howe also wrote textbooks and designed relief maps and other tactile learning aids.

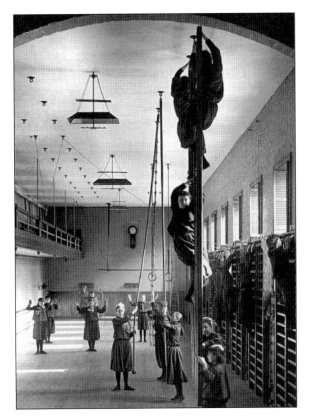

Calisthenics in the South Boston Gymnasium, 1904. Howe strongly believed in physical education for both boys and girls. These girls are dressed in their gym clothes: baggy bloomers, middy tops, and tights. In the foreground, several girls have reached the top of trellislike climbing equipment. A few others are poised to clamber up poles.

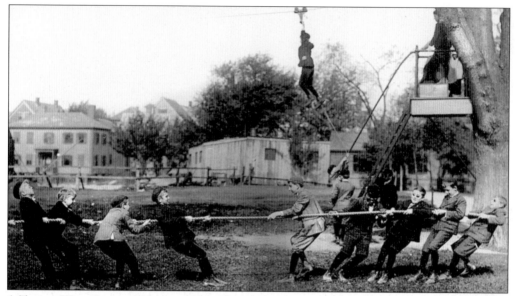

A TUG OF WAR, SOUTH BOSTON, 1908. The Perkins curriculum included rigorous outdoor play from the very beginning. Howe lamented that overprotective families often prevented children from enjoying physical activity, and he insisted on plenty of fresh air and exercise for all students. These boys are tugging on a rope with all their might. In the background, another student slides along an aerial cable strung across the playground.

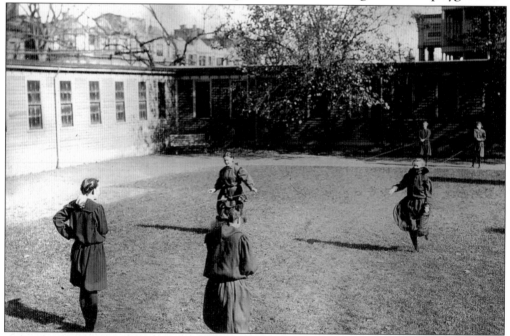

A POTATO RACE, SOUTH BOSTON, 1907. The runners are using cables as a guide, held at either end by students. Howe, delighted by the robust outdoor play of the students at the Paris school for blind children, made sure his students could run and play every day. In the background is the upper portion of the grand Greek Revival portico over the school's main entry. Today, the South Boston Courthouse operates at the site.

16

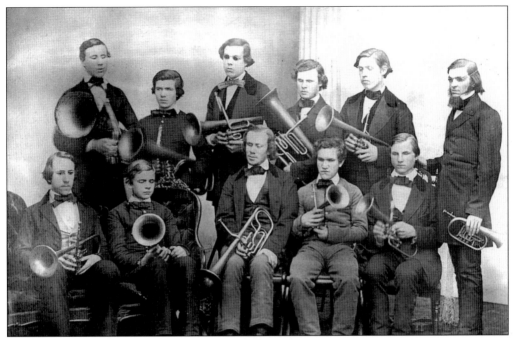

A BRASS BAND, THE 1860S. These young musicians must have made a deep and impressive sound. One has a cornet, and one has a tuba. The remaining nine have euphoniums, or baritone horns. Howe considered music as essential as academics and manual arts, and his third hire was music teacher Lowell Mason. The early schedule included four hours of lessons and practice daily. By the end of Howe's directorship, 5 of the 11 Perkins teachers taught music.

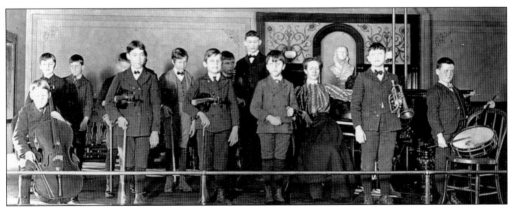

A 12-PIECE BOYS' ORCHESTRA, 1909. These musicians, no older than 10 or 11, already have the poise of seasoned performers. Perkins concerts were popular public events in the 19th and early 20th centuries.

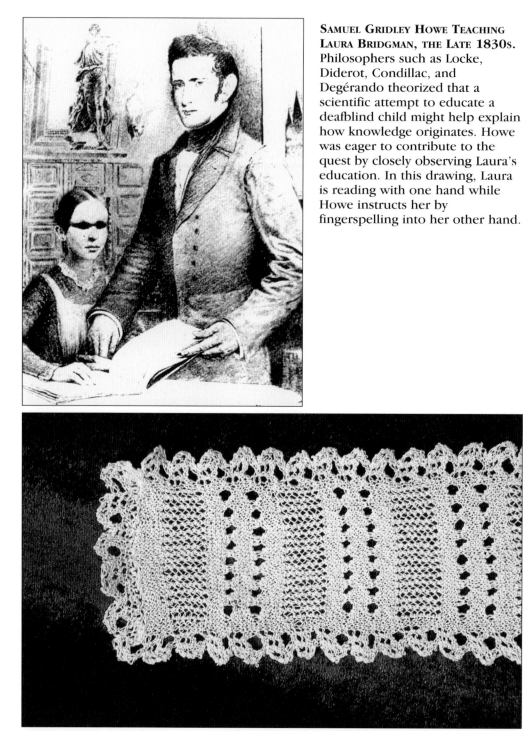

SAMUEL GRIDLEY HOWE TEACHING LAURA BRIDGMAN, THE LATE 1830s. Philosophers such as Locke, Diderot, Condillac, and Degérando theorized that a scientific attempt to educate a deafblind child might help explain how knowledge originates. Howe was eager to contribute to the quest by closely observing Laura's education. In this drawing, Laura is reading with one hand while Howe instructs her by fingerspelling into her other hand.

FINE-GAUGE LACE KNITTED BY LAURA BRIDGMAN. Laura's mother had taught her to knit before she became a student at Perkins. An exquisite needleworker throughout her life, Laura sold her creations for spending money and helped teach sewing and needlecraft at the school.

LAURA BRIDGMAN AS A TEENAGER, C. 1845. The first deafblind person to learn language, Laura Bridgman became world famous during her childhood. Some said Queen Victoria was the only woman better known at the time. On a single day in July 1844, some 1,110 people came to Perkins to see Laura. As Perkins students demonstrated their achievements, some observers doubted they were really blind, so students often wore a silk band over their eyes in public.

— LAURA'S FIRST LETTER —
— AUTOGRAPH FAC-SIMILE COPY —

laura will write letter to mother laura will ride wit with father. laura will make purse for mother laura will sleep with mother and father mother will love ond kiss laura now laura will carry letter for mother laura will go scul be p laura will go home.

LAURA BRIDGMAN'S FIRST LETTER, 1838. As soon as Bridgman learned to write, she sent this letter to her mother. Like all Perkins students at the time, she wrote by placing a sheet of paper over a grooved guide. The grooves guided the right hand across the paper, and the left index finger covered each letter as it was drawn. Because the resulting letters had a square and angular look, this writing technique was called square-hand.

19

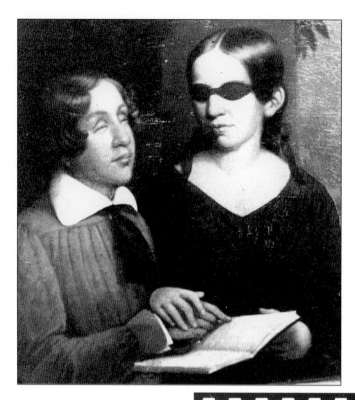

OLIVER CASWELL AND LAURA BRIDGMAN, 1844. This portrait was painted by noted artist Alvan Fisher, brother of founder John Dix Fisher. Caswell was also deafblind, and Bridgman helped teach him language. In this painting, she is guiding his fingers over a page of raised print. Caswell was the same age as Bridgman, but his education began several years later. Although he had an amiable nature and a curious mind, his language skills and intelligence never matched hers.

THE JULIA WARD HOWE POSTAGE STAMP, 1987. The famous poet, orator, social reformer, crusader for woman suffrage, and writer of the abolitionist anthem "The Battle Hymn of the Republic" was married to Samuel Gridley Howe. The Howes lived at the school for many years and reared their six children there. The U.S. Postal Service issued and canceled this stamp at Perkins on its first day of availability.

14 USA

Julia Ward Howe

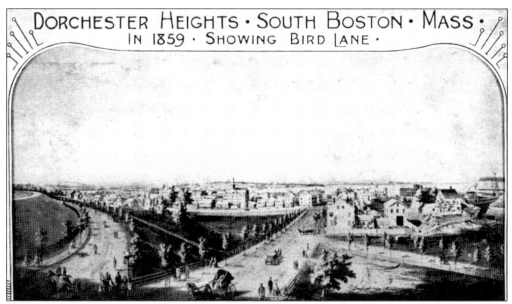

A Postcard of South Boston in 1859. Perkins School for the Blind is at the far right. Over the decades, development changed the rural nature of the neighborhood and hemmed the school in.

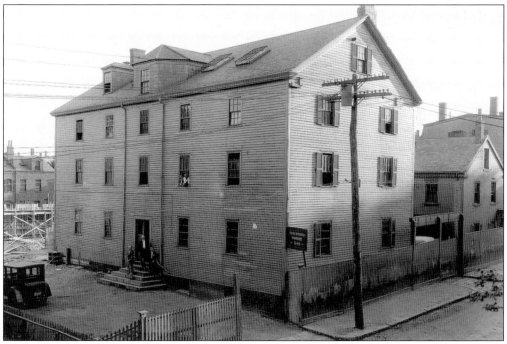

The Workshop for the Adult Blind, South Boston, 1929. This building on East Fourth Street was the facility's home from 1850 until 1929. Founded by Howe in 1837, the workshop provided a livelihood for adults who were blind, many of them school alumni. The principal wares were hand-tied mattresses, feather products, and caned chairs. The building was rebuilt in 1930 and continued in that location until it was closed in 1952. (H. E. Towle photograph.)

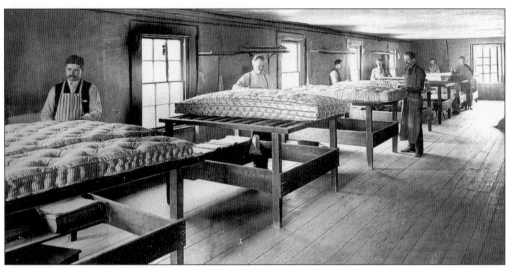

MAKING MATTRESSES, 1906. In the spacious but spare work area of the South Boston Workshop for the Adult Blind, all employees had their own workbenches, where they created mattresses from start to finish. The workshop produced high-quality mattresses, and many families were loyal customers for generations.

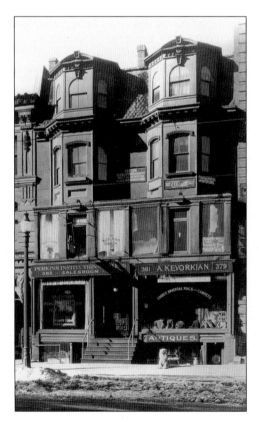

THE PERKINS SALESROOM, 1924. Director Howe maintained a South Boston retail shop to sell the workshop's products from the earliest days. After moving the storefront to this Back Bay location (385 Boylston Street) in 1900, the workshop began to turn a profit. A large photograph of the Watertown campus is displayed in the window. In 1924, the salesroom moved to 133 Newbury Street.

Three

A CHILD'S GARDEN

"Take care of the little blind children." Those were Julia Howe Anagnos's last words to her husband, Michael Anagnos, the school's second director, before she died at age 42. The Anagoses, who never had children of their own, were in the midst of a five-year campaign to build a kindergarten for blind children.

As Perkins had grown, the trustees had decided to accept students from ages 9 to 19. "An essential element was lacking at its base," wrote Michael Anagnos in 1887. Young blind children, mostly from the poorest classes, "are in greater need of early attention and a wise cultivation of their faculties, than their seeing brothers and sisters." Establishing the country's first kindergarten for the blind was among Anagnos's greatest accomplishments.

When Samuel Gridley Howe died in 1876, Michael Anagnos was the natural successor to head Perkins. On an 1866 trip to aid refugees from Turkish rule in Crete, Howe hired the young journalist to help distribute relief funds. Instead of pay, Anagnos asked to be taken to the United States to continue working on the relief effort. In a few years, Howe hired Anagnos to teach Greek and Latin at Perkins. Anagnos quickly became Howe's right-hand man. He also married Howe's daughter Julia, who became deeply involved in the school herself, teaching languages and reading to students.

Anagnos was a ferocious fund-raiser and had a gift for working with people. His first act as director was to set up an endowment for the Howe Memorial Press. He met the goal of $50,000 so quickly that he continued until he had $100,000.

One evening, as the campaign was almost complete, he leaped to his feet and said, "I'll do it!"

"Do what?" Julia asked, looking up from her sewing.

"I'll build a kindergarten for little blind children."

Anagnos admired Friedrich Froebel, the German founder of kindergarten, who believed in letting young children's physical and mental development unfold naturally, by "learning through doing." His curriculum was made up of play, nature, and simple materials such as blocks, paper, and clay. Froebel's ideas were especially well suited to children who were blind, for whom "touch is the master sense," Anagnos wrote. Anagnos's own childhood as an orphan in Greece had been a miserable one, and he vowed "to accept Froebel's grand call to live for little children."

Some trustees had misgivings about starting another large fund-raising campaign so soon, but Anagnos plunged in. Most of the contributions came in small amounts, many from children. Some sold their Christmas presents or sent in earnings for chores. Perkins students raised $2,000 at a fair, selling items they collected and made. Louisa May Alcott wrote a story and donated the $225 fee. Musicians and authors, such as Oliver Wendell Homes, performed at benefits in homes.

In 1885, the school bought six acres at Perkins and Day Streets in Jamaica Plain for $30,000. Wealthy contributors pitched in the additional $33,000 to construct a three-

story brick building to house 32 children, designed by building superintendent and Perkins graduate Dennis Reardon. In May 1887, the kindergarten opened with the 10 neediest applicants.

The school felt like a big cozy house. On the first floor was a parlor with bay windows looking onto the estates of Parker Hill; a kitchen and dining room with long tables, stools, and a cabinet of individually painted mugs and bowls; and separate classrooms for boys and girls. The two upper floors held the girls' and boys' bedrooms, two white beds to each room. The attic served as a playroom.

Anagnos never stopped raising funds to expand the kindergarten, which was soon better endowed than the main school. At the end of his 30 years as director, the kindergarten had grown to 110 pupils, and the campus had four buildings—boys' and girls' kindergartens and primary schools. He had increased the value of the Perkins Institution from $300,000 to $2.2 million and had solidly established the school as a worldwide leader in the education of the blind.

Just as Anagnos had believed that blind children needed guidance at a younger age, educators a century later became convinced that the first three years are the most important learning years—when the physical, social, and cognitive groundwork is laid for future education. Early intervention became the buzzword.

Children learn primarily by observing the actions and emotional expressions they see. Blind children must be systematically taught what sighted children learn naturally—how to hop and run; play with toys; interact with others; and identify letters, numbers, and objects. However, the natural instinct to protect and assist children who are blind can seriously inhibit their development. Today, Perkins's early-childhood teachers work together with families and clinical specialists to actively stimulate each child's learning.

Perkins first offered a summer school for mothers and babies in the 1940s and a daily preschool for deafblind children for several years following the rubella epidemic in the 1960s. Under the leadership of director Charles C. Woodcock, the school in 1979 founded its preschool program, which continues today as the Donald H. Hubbs Children's Center. For many preschoolers who are blind, social development is their most delayed area. Five mornings a week, children play together and make crafts, food, and music at the center—much like any preschoolers. They also gain language and mobility skills, develop their other senses and any partial vision, and learn to use braille and tactile aids.

In 1980, Perkins started the Infant/Toddler Program with a federal grant for a model demonstration project for New England. Teachers visit children with visual impairments at home and, in partnership with their families, help them to achieve developmental milestones such as feeding, crawling, walking, and learning words, all in the course of everyday activities. The program now serves 450 children a year across Massachusetts.

The Perkins Preschool Services program stands as a model of early childhood education that educators from around the world come to observe before starting their own programs.

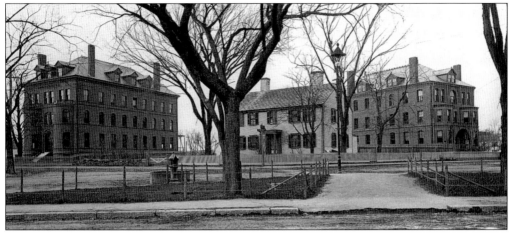

THE KINDERGARTEN FOR THE BLIND, JAMAICA PLAIN'S HYDE SQUARE, 1901. In the late 19th century, epidemics of infectious disease, such as scarlet fever, ravaged the densely packed tenements of manufacturing towns, and blindness in children increased at an alarming rate. More than 50 magazine articles and countless newspaper items were published about director Michael Anagnos's campaign to raise funds for the country's first kindergarten for blind children. Donations came from across the country. (A. H. Folsom photograph.)

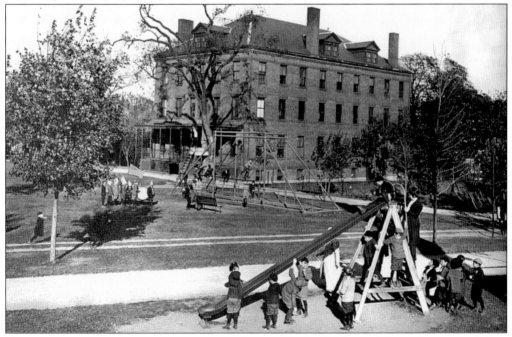

THE KINDERGARTEN PLAYGROUND, JAMAICA PLAIN, 1910. Children slide and swing, while a small color guard band in paper hats provides musical accompaniment. In 1885, Perkins purchased the six-acre estate at Perkins and Day Streets, formerly owned by Revolutionary War general William Heath and later by Boston merchant Leonard Hyde. The facility was well suited to the kindergarten, and the staff was reluctant to move to Watertown in 1913, a year after the upper school. Angell Memorial Animal Hospital now operates at the site.

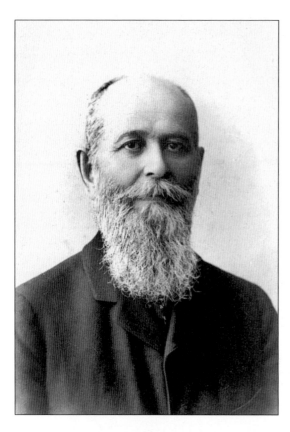

MICHAEL ANAGNOS, PERKINS'S SECOND DIRECTOR, 1876–1906. Greek-born Anagnos, a highly skilled fund-raiser, founded the country's first kindergarten for the blind and set the school on a sound financial course. Often on Sunday afternoons, Anagnos walked the six miles from the main South Boston campus to the kindergarten campus in Jamaica Plain. By saving money on public transportation, he told the children, he could buy them candy. Each time he arrived, they searched his overcoat pockets and usually found some.

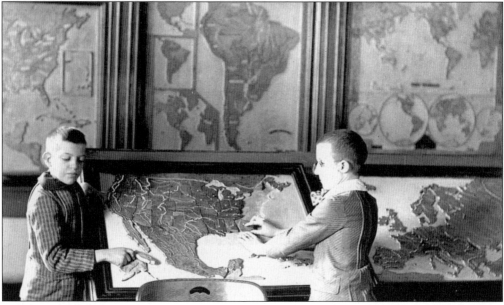

A GEOGRAPHY LESSON, 1893. These kindergarten boys are assembling a puzzle of the United States. A similar map of Europe is nearby. These puzzle maps were manufactured and sold by Howe Press.

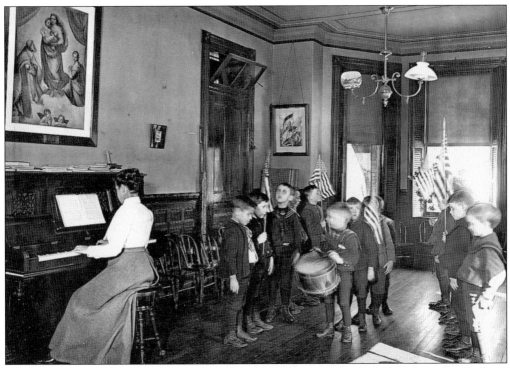

A Kindergarten Music Class, 1909. Perkins has always encouraged music at every level of the curriculum. While the teacher plays the piano, one lucky boy gets to accompany her on a snare drum.

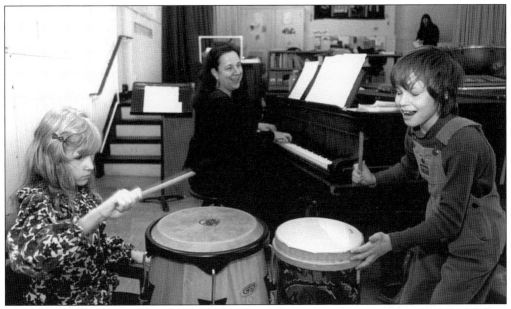

We've Got Rhythm. Just as children did almost a century before, these young children love pounding on drums along with their teacher's piano playing. What they do not know is that they are also developing rhythm, physical coordination, and concentration.

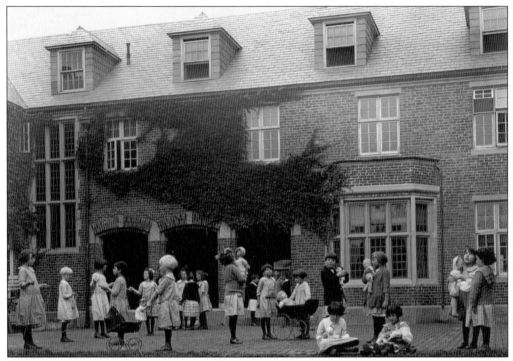

Outdoor Free Time, 1923. Outdoors near the Lower School building, 22 girls enjoy playing with their dolls and talking. The spacious campus in Watertown offered plenty of room to play. (Lila J. Perry photograph.)

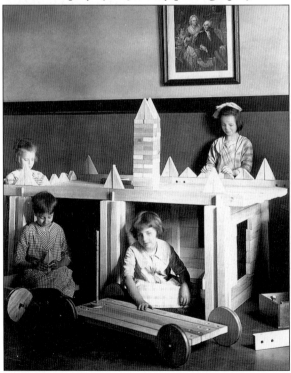

Blocks and Wagons, 1923. Teachers initially balked at the $80 price tag for this collection of toy wooden building materials, but the students loved the blocks. Playing with them was a favorite group activity for years. (Lila J. Perry photograph.)

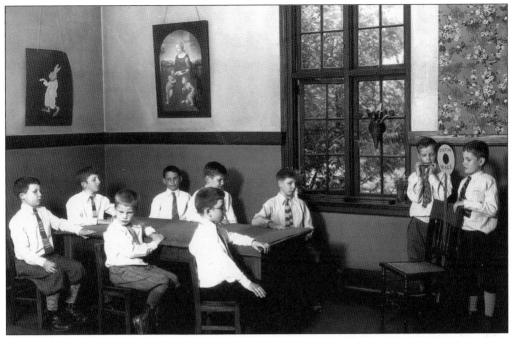

AN ORAL ENGLISH CLASS, 1931. Two youngsters, one on harmonica, perform for their classmates in front of an old-fashioned radio microphone with the station call letters WACK. (Henry E. Towle photograph.)

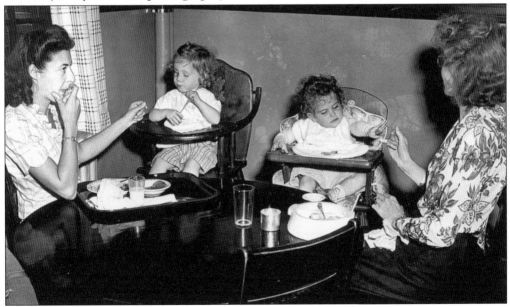

THE BABY SCHOOL. During the 1940s, many premature infants became blind as a result of excess oxygen therapy. Perkins developed the innovative baby school to help infants develop physical, cognitive, and language skills, which are profoundly affected by congenital blindness. In this forerunner of the current Perkins Infant/Toddler Program, mothers and infants together learned techniques, games, and activities that stimulated those developmental areas.

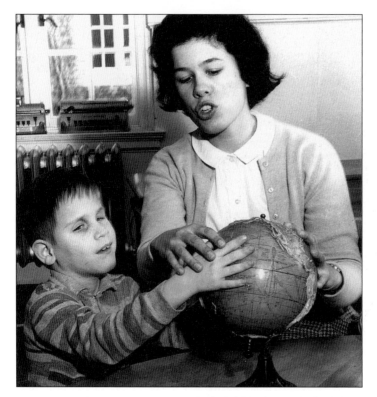

EXPLORING THE WORLD, THE 1960s. Relief maps and globes are useful educational tools that have been used throughout the history of education for students who are blind. This globe is well suited to small hands.

CHARLES C. WOODCOCK, PERKINS'S SEVENTH DIRECTOR, 1977–1984. Woodcock supervised the founding of the Perkins Preschool and Infant/Toddler Program, now called Preschool Services. He established employment, vocational training, and community living programs and supervised an overhaul of the campus to make it accessible to students with mobility impairments.

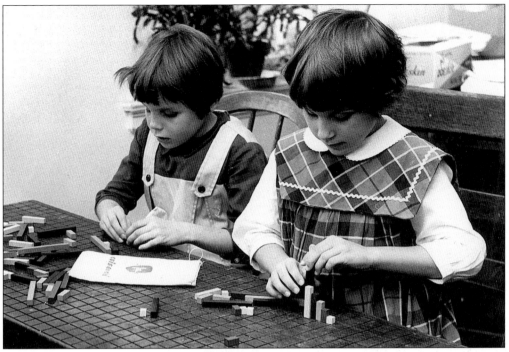

A Tactile Arithmetic Lesson, the 1960s. These Lower School girls are using Cuisenaire rods. Sticks of varying lengths help students understand the relationships of numbers.

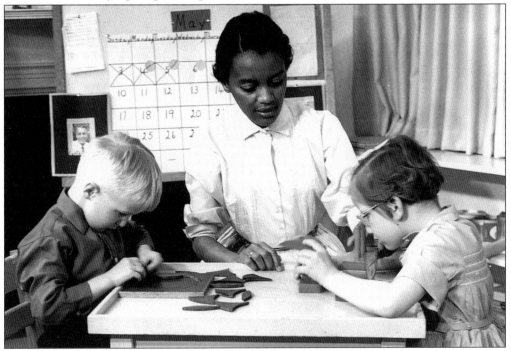

Puzzling over Shapes, the 1950s. This teacher is guiding two young students working with puzzles. The boy's puzzle is geometric, and the girl's is three-dimensional. This play improves the children's coordination and spatial understanding.

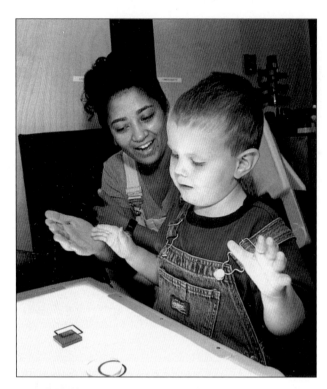

VISION STIMULATION. Babies born with low vision need to be encouraged to use their remaining vision and to integrate it with their other senses. This teacher is using a light box to stimulate the toddler's limited usable vision.

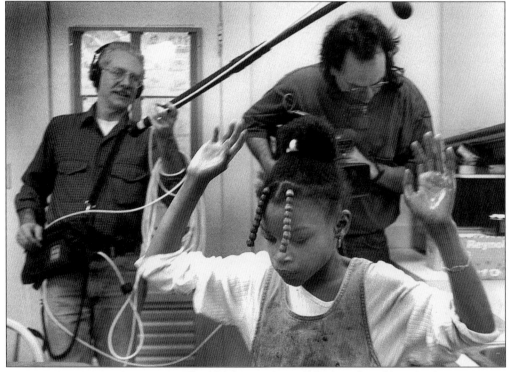

PERKINS ON PUBLIC TELEVISION. The WGBH cartoon show *Arthur* filmed a live segment of Lower School students baking cookies in 1998.

ORIENTATION AND MOBILITY LESSON. An early start is important in learning how to get around independently. This preschool boy is exhibiting great confidence and skill.

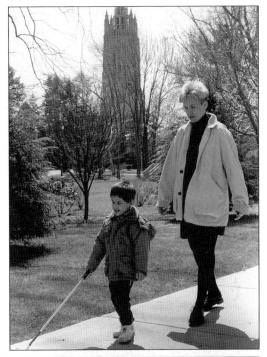

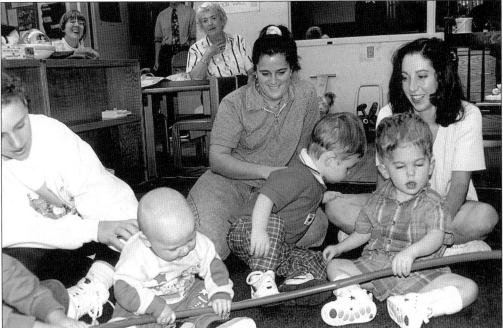

CIRCLE TIME. The Perkins Infant/Toddler Program, founded in 1980, helps youngsters achieve developmental milestones such as sitting up, crawling, and feeding. Young children learn about their environment mostly through vision. Early intervention can help children with low vision keep on track. Teachers visit families at home once a week, and parents come to the school throughout each month. Many Perkins preschoolers can later attend local public schools with classmates of their own age.

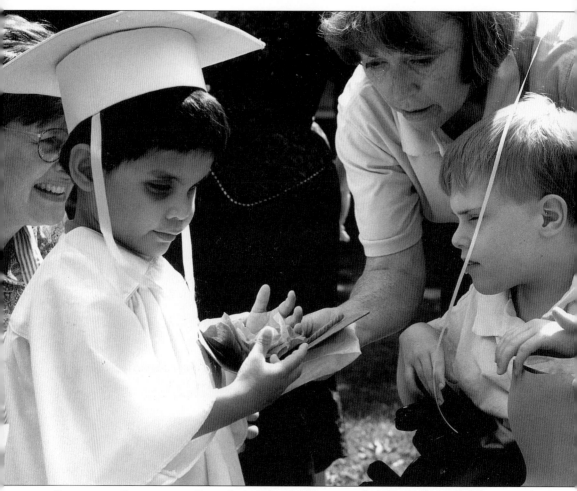

PRESCHOOL GRADUATION. Completing the Perkins Preschool calls for celebration and gift giving. These children have learned how to move around confidently and independently, how to interact with their peers, and how to make sense of the world around them. They have also made a start on the tactile skills that are the foundation of braille literacy. These important abilities will be indispensable as they continue their education and throughout their lives.

Four

HELEN KELLER
AND ANNIE SULLIVAN

Helen Keller's first trip to Boston at age seven to visit Perkins School for the Blind "seems to have been the beginning of everything," she wrote in *The Story of My Life.* Her years at Perkins, from ages 8 to 12, opened up worlds for the deafblind girl from Alabama—literature, music, languages, new teachers, fame, and most important, children who could talk with her.

Her international fame was due in large part to the school's second director, Michael Anagnos, who had unbridled enthusiasm for her intellect, accomplishments, and sweet nature. The deafblind girl who transcended her disabilities and later wrote books and made speaking tours for what she believed in became one of the best-loved Americans of all time.

Born a precocious child, Keller suffered a severe fever at 19 months that left her deaf and blind. With only a few simple signs to communicate, the little girl became uncontrollable. Her mother had read with great hope Charles Dickens's *American Notes,* describing Samuel Gridley Howe's work with his deafblind student Laura Bridgman at Perkins. The Kellers wrote to the school, and Anagnos recommended class of 1886 valedictorian Annie Sullivan as Keller's governess and teacher. The pay was room, board, and $25 a month.

Sullivan's life story and achievements are inseparable from Keller's and equally remarkable. The orphan of Irish-famine refugees, Sullivan had spent her childhood in a squalid poorhouse in Tewksbury with her brother, who died there. Untreated trachoma left her nearly blind. At age 14, she cried out for help to Frank Sanborn, a Massachusetts Board of Charities investigator inspecting the asylum, who was also a Perkins trustee. Soon after, she was enrolled at Perkins, quite unhappily at first. Some teachers resisted working with the uncouth, illiterate, and tempestuous teenager. At least once she was threatened with expulsion. Not fitting in with the more cultured girls her age, Sullivan became close to Laura Bridgman, who was then in her 50s, and mastered spelling into her hand with the manual alphabet.

Sullivan worried that she would be unable to find useful work after graduating and was grateful for the opportunity to teach. She spent several months preparing, reading Howe's descriptions of his work with deafblind students.

Just 21, she instinctively developed her own methods. First, she separated Keller from her overprotective family by moving with her to a cottage on the Keller farm and instituted firm discipline. Rather than using prepared labels as Howe had, she fingerspelled into Keller's hand from the start. She constantly named whatever drew the little girl's attention, just as one would with a preverbal hearing child, trusting that

Keller would learn through repetition and context. The natural world became their private classroom. Her techniques are still fundamental in deafblind education.

After five weeks with Sullivan, Keller connected the sensation of water running over one hand with w-a-t-e-r spelled into the other. Suddenly, she understood that everything had a name and that there was a system of language she could use to communicate. This was the breakthrough that became immortalized in the 1957 play *The Miracle Worker.*

Yet Keller, who had no memory of that day any more than toddlers remember their first words, reserved the word "miracle" for a second breakthrough: the day she realized, on her first visit to Perkins, that she could communicate with her peers. "What joy to talk with other children in my own language!" she wrote in her autobiography. "Until then I had been like a foreigner speaking through an interpreter. In the school where Laura Bridgman was taught I was in my own country."

Anagnos invited Helen Keller and Annie Sullivan to stay indefinitely at the school, where both thrived. Perkins teachers gave lessons in basketry, clay modeling, Greek, Latin, and French—the last of which Keller mastered in an astonishing few months. Sullivan always had final authority over Keller's education, however.

Keller's world expanded at breakneck speed. She met and corresponded with intellectual luminaries of the time—Oliver Wendell Holmes, John Greenleaf Whittier, Bishop Phillips Brooks, and Alexander Graham Bell. On her own, she solicited money to bring a deafblind boy, Tommy Stringer, from a Pennsylvania poorhouse to Perkins.

Michael Anagnos was enthralled with the brilliant, good-hearted young pupil and treated both her and Sullivan as adored daughters, paying all their expenses. In hundreds of pages in Perkins reports, he lavished praise on Keller: "She is the queen of precocious and brilliant children, Emersonian in temper . . . a true daughter of Mnemosyne." Sullivan objected to his excesses: "His extravagant way of saying [kind things] rubs me the wrong way. The simple facts would be so much more convincing!"

At age 11, Keller sent Anagnos a story she had written called "The Frost King" as a birthday gift. Delighted, Anagnos published it. Soon after, the editors learned the story was almost identical to one called "The Frost Fairies," by children's author Margaret Canby. Keller was devastated by the charge of plagiarism. Apparently, the story had been read to her three years before. She had retained the words but not the memory of having been read to.

Anagnos called Keller before a "court of investigation" made up of eight school officers and cast the deciding vote in her favor. Their warm relationship did not survive their separate humiliations, however. Soon afterward, Helen Keller and Annie Sullivan left Perkins. Keller never tried to write fiction again. In her many books, she always worried about her difficulty separating memory and imagination, without firsthand sensory experience.

Historians still criticize Anagnos's role in the debacle. His actions become more understandable in historical context; in battling the attitude that blind people could not be educated, both Howe and Anagnos publicized their students' accomplishments in the flowery writing style of the day. Still, many suspected fraud or tricks. When public questioning of the school's and Anagnos's own credibility grew, "some sort of 'official' investigation was probably unavoidable," as Edward J. Waterhouse, Perkins's sixth director, wrote in 1980.

Sixty years passed before Helen Keller visited Perkins again, at the current campus in Watertown. In 1956, at age 76, she dedicated a cottage for deafblind students, now called Keller-Sullivan and used for home economics and student housing. Fifty-nine Perkins students sang at Helen Keller's memorial service in the National Cathedral in Washington, D.C., in 1968.

ANNIE SULLIVAN, VALEDICTORIAN, CLASS OF 1886. Annie Sullivan arrived at Perkins at age 14, visually impaired and illiterate. Abandoned by her family, she spent much of her childhood in an almshouse in Tewksbury. At Perkins, her eager drive and intelligence took her to the head of her class. Her feisty temperament earned her the nickname Little Miss Spitfire.

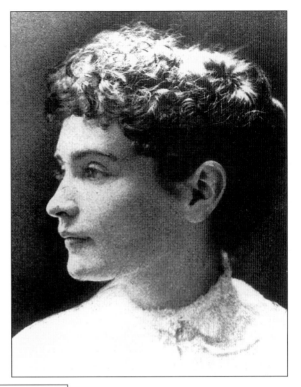

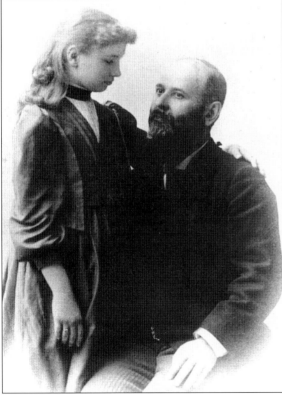

HELEN KELLER WITH MICHAEL ANAGNOS, c. 1890. When the Keller family of Alabama wrote asking for a teacher for their six-year-old daughter who was deafblind, Anagnos selected recent Perkins graduate Annie Sullivan. Anagnos paid all of Keller's and Sullivan's expenses while they were at Perkins. He wrote hundreds of pages about Keller's accomplishments in Perkins reports. In just a few years, Keller was internationally famous.

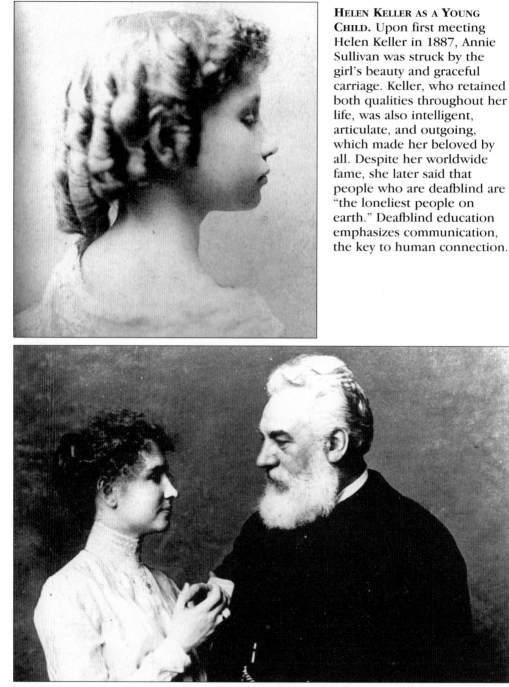

HELEN KELLER AS A YOUNG CHILD. Upon first meeting Helen Keller in 1887, Annie Sullivan was struck by the girl's beauty and graceful carriage. Keller, who retained both qualities throughout her life, was also intelligent, articulate, and outgoing, which made her beloved by all. Despite her worldwide fame, she later said that people who are deafblind are "the loneliest people on earth." Deafblind education emphasizes communication, the key to human connection.

HELEN KELLER WITH ALEXANDER GRAHAM BELL, 1901. Keller was six when she met Bell, a teacher of people who are deaf. She later wrote, "He understood my signs, and I knew it and loved him at once. But I did not dream that that interview would be the door through which I should pass from darkness into light, from isolation to friendship, companionship, knowledge, love." The Keller family's search for help led them to Bell, who recommended that the family write to Perkins for a teacher for Keller.

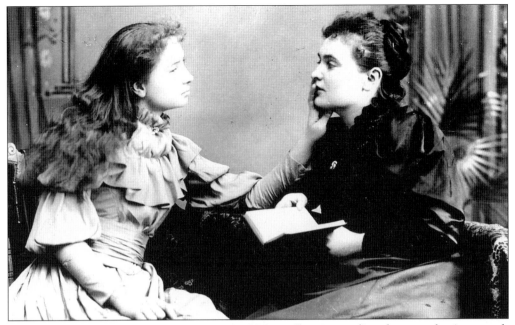

HELEN KELLER AND ANNIE SULLIVAN, *C.* **1892.** Keller is reading her teacher's speech tactilely. By holding her hand to Sullivan's face, Keller can identify the sounds being formed. Keller preferred this method of communication, but she also used fingerspelling. While at Perkins, she studied speech at the Horace Mann School in Boston and, later, at the Wright-Humason School for the Deaf, but she was never satisfied with her ability to make herself understood.

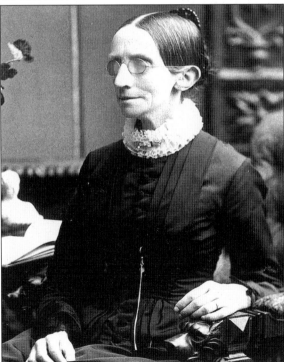

LAURA BRIDGMAN, *C.* **1885.** On their first visit to Perkins, Annie Sullivan had so looked forward to introducing Keller to her friend Laura Bridgman, who had made a dress for Keller's doll. The meeting went poorly, however. Bridgman did not like the child grabbing her face or her needlework and scolded Sullivan for not teaching her better manners. When the ebullient Keller tried to kiss Bridgman goodbye, she accidentally stepped on the frail woman's toes.

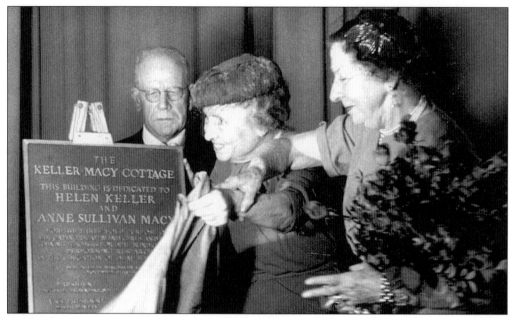

HELEN KELLER DEDICATING THE KELLER-MACY COTTAGE, 1956. Keller unveils the bronze plaque with the new name for the Perkins Deafblind Department building, honoring her and her teacher, Annie Sullivan Macy. Polly Thomson, who became Keller's interpreter after Sullivan's death, accompanies her. Later, the cottage's name was changed to Keller-Sullivan to reflect the name by which Annie Sullivan is most widely known.

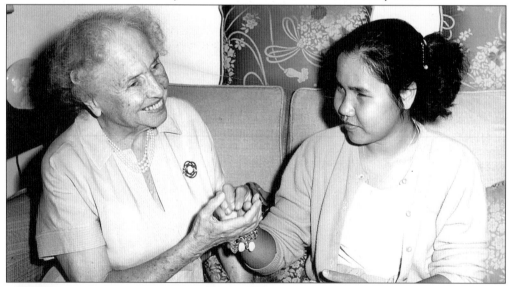

HELEN KELLER AND CHAN POH LIN, 1961. Singapore native Chan lost her sight and hearing at age 11 and came to Perkins with her English-speaking teacher to further her education. She is one of the many people who are deafblind who have benefited from Helen Keller's lifelong work promoting deafblind education and public awareness. In 1961, Keller invited the Perkins student to her Connecticut home. Chan went on to teach for the Singapore Association of the Visually Handicapped. (Courtesy Campbell Films.)

Five

A SENSE OF PLACE

The best way to show a newcomer the Perkins campus, some say, is to say as little as possible. The lovely gothic buildings, topped by the school's signature bell tower, gracefully set on the rolling campus, and the teachers and students going about their work—all speak for themselves.

On becoming the school's third director in 1907, Edward Allen quickly determined that Perkins needed a new home. New construction in South Boston was cramping the former hotel that had served Perkins for 75 years. The school's multistoried wooden structures in South Boston and in Jamaica Plain were fire hazards. Managing nearly 400 students in two locations six miles apart had become unwieldy.

In 1910, Allen found the perfect site for Perkins: the 38.5-acre estate of whaling and sugar merchant Josiah Stickney, overlooking the Charles River in Watertown, for $31,844.62. In addition to 1,600 feet of river-park frontage, the property had fruit and shade trees, grounds for gardens, a small pond for rowing and skating, and it was 10 minutes' walk to shops and churches in the town center.

Architect R. Clipston Sturgis designed the new campus in the popular architectural style for schools and churches of the day called English collegiate gothic. The buildings are constructed of fireproof brick with slate roofs, designed low and narrow for easy egress, with gables, bays, and arched windows relieving the architectural lines.

Two requirements guided Sturgis's design. Allen was an enthusiastic believer in the family-style cottage plan developed by Perkins's first director, Samuel Gridley Howe. "A sense of ownership, part proprietorship, is fostered, and with this much of the discipline usual in institutions disappears," he wrote. A matron, four teachers, a cook, and a household assistant oversaw 20 students in each cottage. The arrangement helped teach students skills for living.

Classroom, living, and playing spaces, and even walkways, should be kept strictly apart for girls and boys "for economic and eugenic reasons," Allen specified. At the time this was common school practice, and some believed, even more important for students with genetic disabilities.

The 180-foot bell tower dominates the campus landscape. It is topped with a lantern, a symbol of education, which is also the namesake of the school publication, founded in 1931 by director Gabriel Farrell. A spiral staircase ascends through the hollow tower to the eight English change-ringing bells, donated in 1913 by Mrs. Andrew C. Wheelwright, a descendant of Thomas Perkins. Today, the bells are automated to ring the Westminster chime on the quarter hour.

The main Howe Building is two squares, each circumscribing an outdoor quadrangle, originally one for girls and one for boys. The building houses a chapel, a museum of tactile teaching objects such as taxidermy, a performance hall, a library, classrooms, a gymnasium, and a pool.

In 1961, a second gymnasium was built to accommodate wrestling, basketball, indoor roller-skating, and bowling. Speakers and floor patterns signal when skaters should turn, and metronomes provide audible signals to mark the basketball goals. Tracks above both gyms are lined with guide railings—brass in the original—and an outdoor track built in the late 1970s is equipped with a cable and spool for the 50- and 70-yard dashes. The surface of the indoor pool was built higher than the walkway so that swimmers could not fall in accidentally. Today, a lift assists swimmers with physical disabilities.

At either end of the Howe Building are two sets of facing cottages, originally boys on the east and girls on the west, nine in all, including a domestic science house on the girls' end. The cottages face a close, or pathway, originally brick and lined with walls—inspired by the early medieval Vicars' Close of Wells Cathedral in England. Today, all but two cottages are coeducational, with deafblind students in the East Close and secondary students in the West Close.

The Lower School, also designed as a square around a great court, is separate to the northwest. Under one roof are classrooms, a gymnasium, an auditorium, and four cottages, initially one each for girls' and boys' kindergartens and primary schools, each with its own dining room. Three other buildings completed the original campus: the Howe Press and powerhouse for maintenance functions, the director's house, and an infirmary with four suites. More than a half-mile of tunnels connects the original buildings.

Sturgis built in numerous considerations to ease students' mobility: straight equidistant corridors, right angles, and stairs on the sides of corridors. Walkways are slightly crowned to help students maintain their sense of direction. The stage in the performance hall is upturned at the edge. Tactile guides are everywhere—varied floor tiles at corridor ends, animal tiles on the museum's columns, carved rosettes marking the seats of the chapel. Ramps and elevators were added in an extensive renovation during the 1970s. Today, tactile symbols mark each door—a glove for Glover Cottage, a little aluminum pot for Potter Cottage, lips for speech therapy.

The campus design has served remarkably well for nearly 100 years, with a few additions, now totaling 32 buildings. In 1970, architect Edward Diehl designed the Northeast Building, with apartments for teacher trainees and parents bringing children for evaluation (today the Preschool Program and Outreach Services); and the North Building (now the Conrad N. Hilton Building) for the Deafblind Program. In 2003, the Thomas and Bessie Pappas Horticulture Center—a magical sunny greenhouse filled with plants chosen for touch, scent, and visual appeal—was opened for horticultural therapy, vocational training, and classes.

Edward Allen, a hobby arboriculturist, loved the estate's native trees and planted many others. Today, more than 45 tree species grace the campus, many of which are identified in braille and Roman print—maples, oaks, walnuts, ashes, lindens, willows, elms, and a yellowwood tree that is the only known specimen in the world to bear pink blossoms. Over the years, some 20 ornamental trees, such as dogwood, cherry, and magnolia, have been planted on campus as living memorials to students and staff.

Donald Hubbs, head of the Conrad N. Hilton Foundation, remembers of his first visit: "It's a beautiful, lovely setting, one that gives a real feeling of permanence."

THE PERKINS MANSION, 1833–1839. Col. Thomas Handasyd Perkins, a wealthy Boston merchant and a founding trustee and vice president of the school, donated the use of his Pearl Street house on condition that the school raise $50,000 in a month, a challenge to ensure the institution's continued growth. Charity bazaars organized by Salem and Boston women's groups quickly raised nearly twice that amount. This site is now part of Post Office Square in Boston.

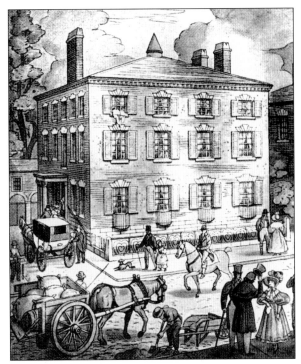

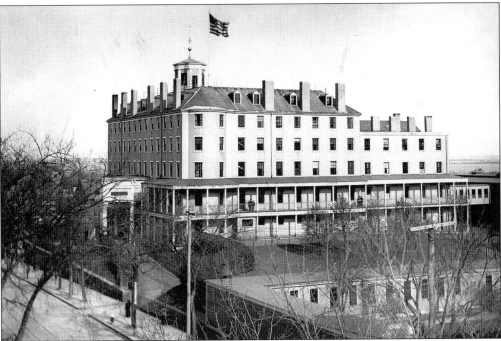

THE SOUTH BOSTON CAMPUS, 1839–1912. The school moved in 1839 to Mount Washington House, a hotel that had gone bankrupt. Purchased for $20,000, the facility was new, large, easily adapted, and close to the ocean, and had plenty of open space. Director Samuel Gridley Howe required all students to bathe in the sea daily. During the winter, he permitted them to plunge instead into vats of cold water in the basement.

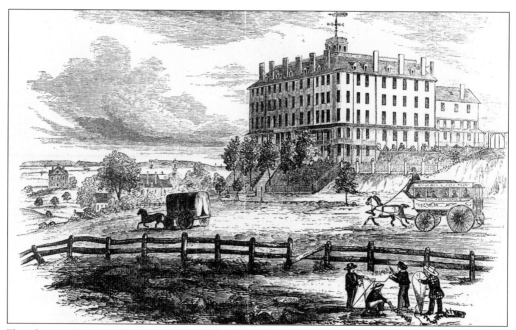

THE SOUTH BOSTON CAMPUS, THE 1850s. This lithograph was made soon after the city of Boston regraded and lowered the streets by 15 feet, leaving the school perched on a steep bank. A long flight of stairs was installed to restore access from the street. Fences were erected to prevent students from accidentally rolling down the 30-foot embankments bordering the playgrounds.

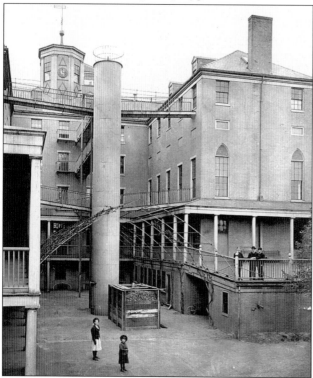

THE REAR OF THE MAIN BUILDING, SOUTH BOSTON, c. 1905. The school added these two wings on the back of the main building. The cylinder in the center is a spiral fire escape, with catwalks leading from each floor. This photograph provides a good view of the building's distinctive octagonal tower and its clock, fondly nicknamed Jonah.

THE GIRLS' COURTYARD, SOUTH BOSTON, 1900. Girls' cottages surrounded their schoolhouse in South Boston. Introduced in 1870, the cottage system houses students, teachers, and houseparents in small, family-like groups. Because of cost and limited space, the boys remained in dormitories in the main building until the 1912 move to Watertown. In the background is Hawes Unitarian Church, since 1950 the home of the Albanian Orthodox Cathedral of St. George.

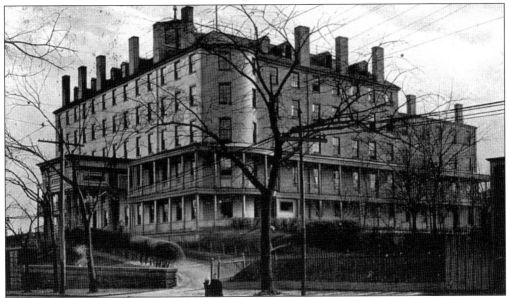

A POSTCARD VIEW OF THE SOUTH BOSTON CAMPUS, THE EARLY 1900s. Perkins was a popular tourist attraction, and printing its image on postcards publicized its work and welcomed visitors. Each week, students entertained guests with public exhibitions of their academic skills. State legislatures provided much of the school's early income, and exhibitions fostered public support by demonstrating the value of educating children who were blind.

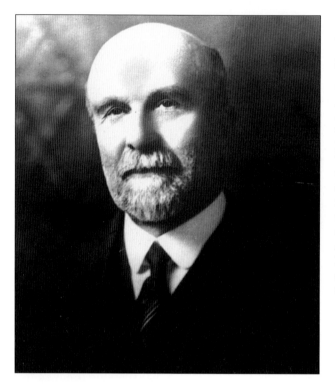

EDWARD ELLIS ALLEN, PERKINS'S THIRD DIRECTOR, 1907–1931. Allen moved the school to its Watertown location and started the teacher training program. He incorporated Montessori methods and employed social workers, psychologists, and speech therapists. He also introduced corrective gymnastics, addressed the educational needs of Perkins students with multiple disabilities, and in collaboration with the American Foundation for the Blind, started an experimental department to research educational methods.

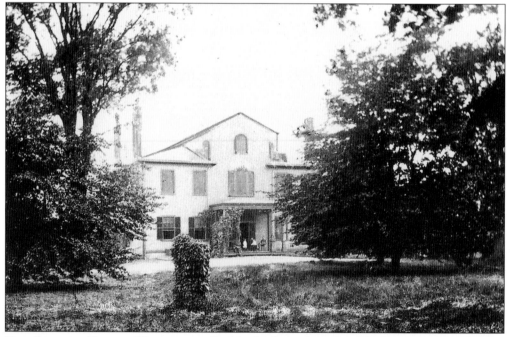

THE STICKNEY ESTATE, WATERTOWN. Josiah Stickney bought this house in 1844 from Benjamin Faneuil Hunt Jr., the grandson of William Hunt, the builder of the home. Perkins purchased the 38.5-acre estate in 1910 for nearly $32,000 and demolished the house to make way for the school's Howe Building. (Courtesy Watertown Free Public Library.)

46

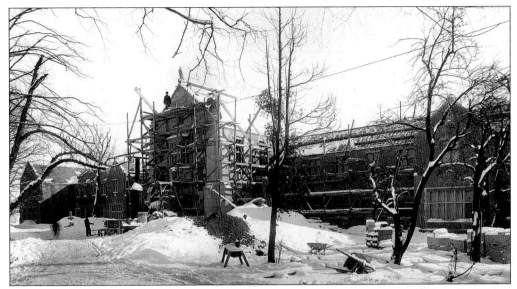

THE HOWE BUILDING, FEBRUARY 1912. In this photograph, the building is largely complete, including windows and roof tiles. The foreground is strewn with snow-covered wheelbarrows and stacks of massive cornerstone blocks. The Watertown campus opened in the autumn of 1912. The tower was still under construction, and contractors occupied the chapel and some classrooms until the school was finished months later. (A. H. Folsom photograph.)

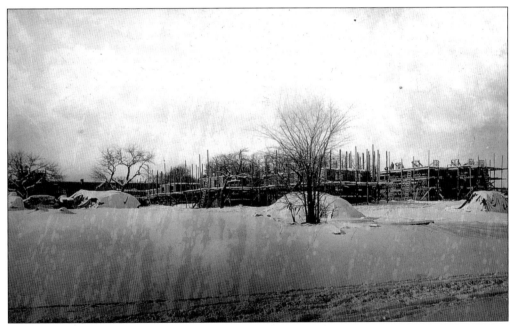

A VIEW FROM BEECHWOOD AVENUE, FEBRUARY 1912. The boys' cottages, on the east, were in the early stages of construction when this photograph was taken. Thus, the brick cottages' distinctive peaked and scalloped roofline has not yet been created. At the far left, the scaffolding for the bottom of the Howe Building tower is visible through the tree branches. (A. H. Folsom photograph.)

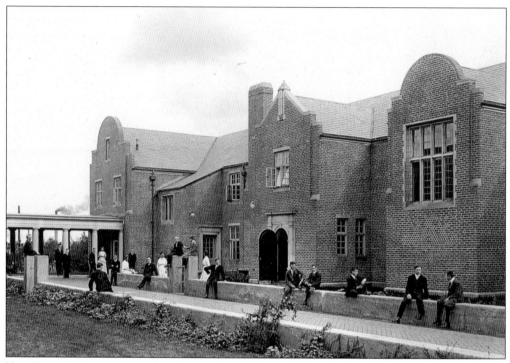

THE EAST COTTAGES, C. 1913. The boys' cottages, pictured shortly after completion, are not yet covered with the ivy that enshrouded them in later years.

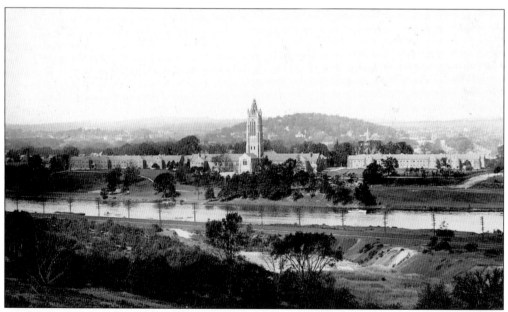

THE WATERTOWN CAMPUS, C. 1913. The sparsely wooded riverbanks at the time afforded a clear view of the campus. The 180-foot Perkins tower is crowned with its symbolic lantern of education. Architect R. Clipston Sturgis designed the tower both to inspire those who work and study beneath it and, as director Edward Allen specified, to "invite the wondering public in."

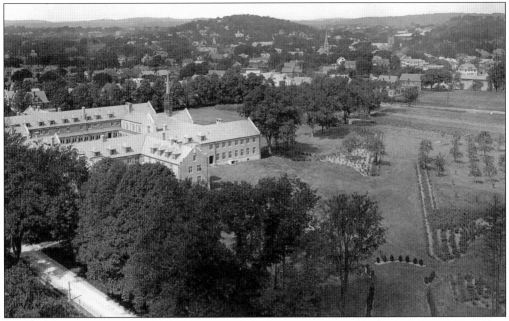

Looking Northwest, c. 1913. One of the earliest photographs taken from the Perkins tower shows the Lower School campus amidst expansive lawns and cultivated fields. On its 38.5 acres, Perkins offered agriculture and animal husbandry as part of the curriculum. These activities provided students with both exercise and useful chores, as well as eggs, poultry, fruit, and vegetables for the cottage kitchens.

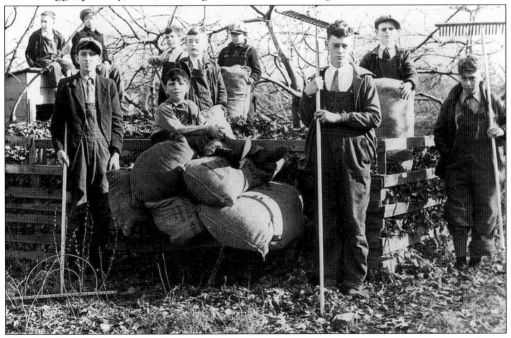

Making Compost, 1934. These Lower School boys are creating a compost bed in a three-foot-high bin. Four boys are inside the bin, emptying bags of leaves and compacting them with their feet. The older boys wielding rakes are gathering the leaves.

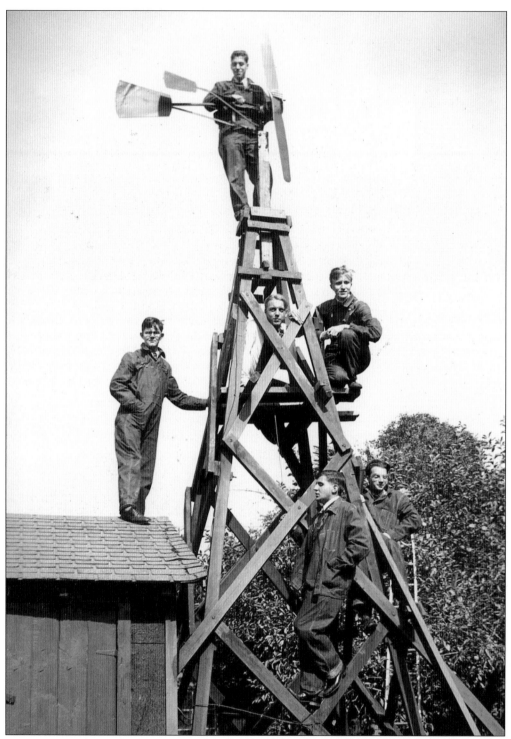

A Junior Perkins Tower, the 1920s. The builders of this windmill for the campus poultry house triumphantly pose atop it. Many graduates were prepared for careers working with poultry.

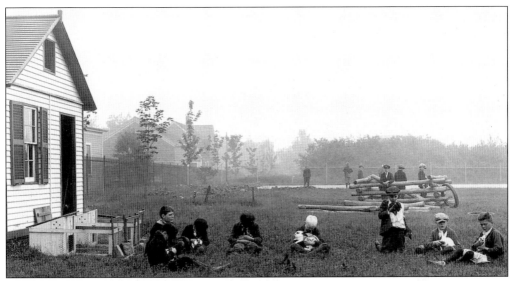

ANIMAL HUSBANDRY, 1923. Having removed some rabbits from their hutches, these six Lower School boys cannot resist sitting and cuddling the animals. Every semester, several students had complete responsibility for the rabbits' care. Even though it required getting up early every day, students vied for the job. (Lila J. Perry photograph.)

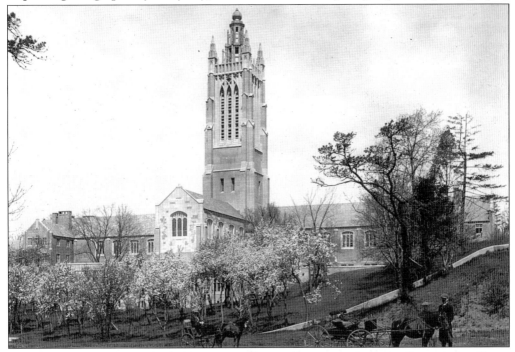

CHARLES RIVER ROAD, 1916. Two open horse-drawn carriages pull past the Howe Building on a brilliant spring day. A pear orchard is in full blossom on land now occupied by one of the school's four gymnasiums and a parking lot. The school's trustees chose the Watertown site in part because of its many fruit trees. Over the years, many ornamental trees have been planted on campus as living memorials and for beautification, and the riverfront has grown in with woods.

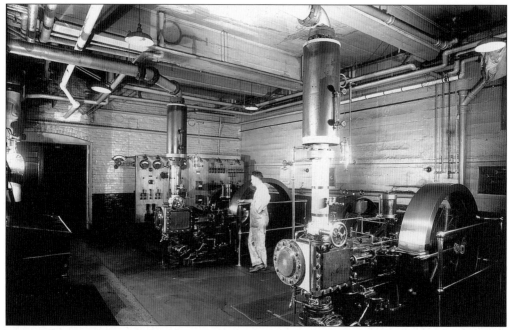

THE POWERHOUSE, THE 1920s. For many years, Perkins generated its own electricity and steam heat from this building. During the 1965 Northeast blackout, Perkins never lost power, and campus residents became aware of the crisis only from the radio. The home of Howe Press for more than 50 years, the former powerhouse, with its tall smokestack, is still a prominent feature on the campus's west side. (Dodman photograph.)

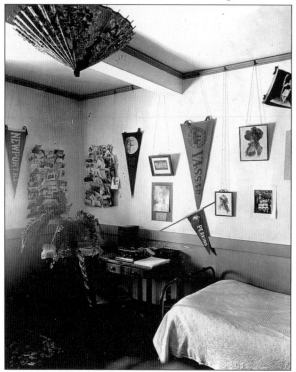

THE UPPER SCHOOL COTTAGE, *c.* **1910.** This cozy and well-decorated room was home for two students during the school year. The Vassar pennant and the Gibson girl fashion drawing are clues that the students were girls. An early Perkins Braillewriter has pride of place on the desk. (M. Mabey photograph.)

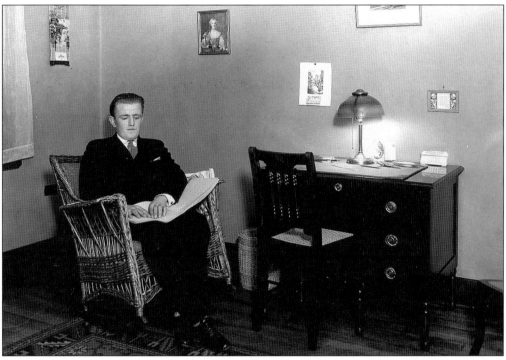

THE TOMPKINS COTTAGE, 1932. A teacher relaxes and reads in the sitting room. The cottage is named after benefactor Eugene Tompkins. (Henry E. Towle photograph.)

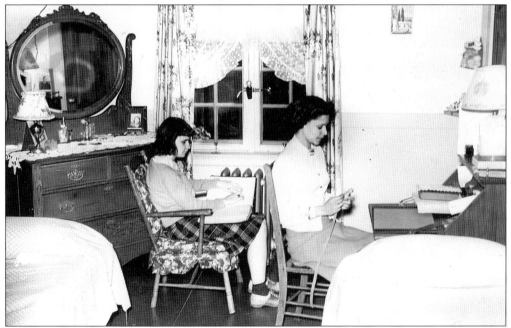

A COTTAGE ROOM, THE 1940S. One student is knitting at her desk, while her roommate studies a braille textbook near the radiator. The Victorian-era dresser and scarf, chenille bedspreads, and cheerful curtains make the small room welcoming and homelike. Sharing cottage rooms encouraged students' social skills and "unselfishness."

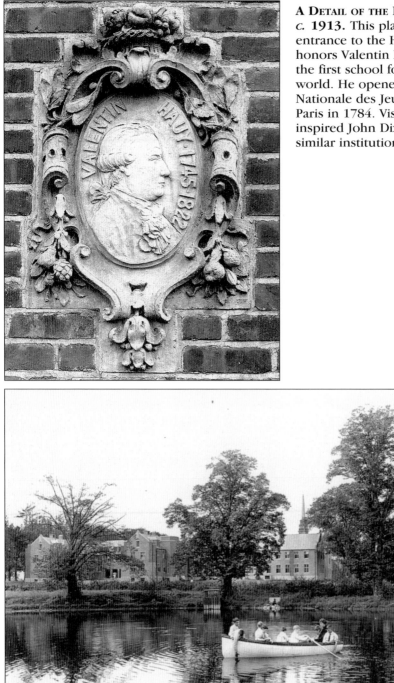

A Detail of the Howe Building,
c. **1913.** This plaque over the west
entrance to the Howe Building
honors Valentin Haüy, founder of
the first school for the blind in the
world. He opened L'Institution
Nationale des Jeunes Aveugles in
Paris in 1784. Visiting this school
inspired John Dix Fisher to found a
similar institution in New England.

Perkins Pond, 1915. Two small boys are rowing a boatload of eight students and a
teacher. Visible through the trees is the spire of the Lower School fleche, which is
a slender openwork spire. A teacher and her class of girls on the bank are reading
braille books. Before the school bought the Stickney estate, its owners harvested and
stored ice from the pond and sold it for iceboxes in the warmer months.

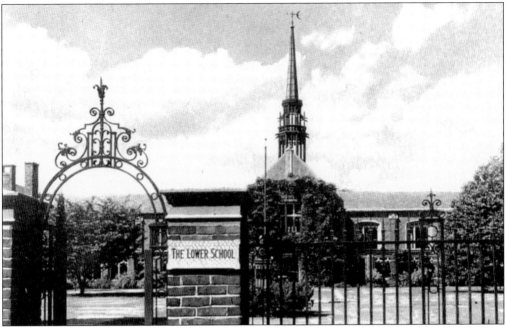

THE LOWER SCHOOL, 1932. Margaret Bourke-White created many campus photographs for the Perkins centennial. Her mother worked at the school from 1931 to 1936. At age 28, Bourke-White had already established herself as an accomplished architectural photographer. Her postcard views of Perkins were available for many years. (Margaret Bourke-White photograph.)

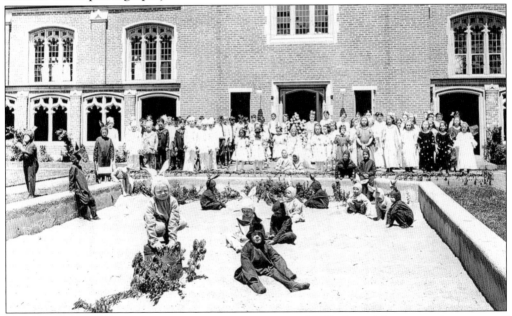

THE SPRING FESTIVAL, LOWER SCHOOL COURTYARD, MAY 1915. One girl seems to be queen of the May, with other girls dressed as her ladies-in-waiting. The smaller boys are obligingly hopping about in bunny costumes, with hoods and perky ears. The sandbox was removed soon after because it proved popular with neighborhood cats. (M. Mabey photograph.)

THE DIRECTOR'S COTTAGE, THE 1930s. After a new residence was built for director Edward Waterhouse and his family in the 1950s, this building housed the Perkins Deafblind Department. Renamed the Keller-Sullivan Cottage, it is now a center for classes in home and personal management. Here, students learn independent living skills such as cooking, sewing, money management, and cleaning. The building also houses older students and prepares them for independent living. (Margaret Bourke-White photograph.)

TWO SOARING SYMBOLS, THE 1930s. This photograph has an unusual perspective, as the spire of the Lower School fleche, in the foreground, appears to dominate the taller Howe Building tower.

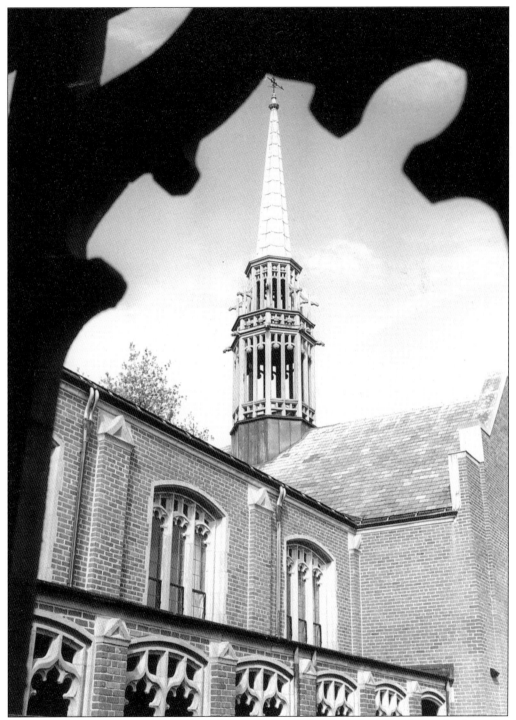

THE LOWER SCHOOL FLECHE. This photograph of the Lower School emphasizes the beautiful design found throughout the Perkins campus. The strong and simple lines of the building's basic form are softened by the complex, curvaceous detail on the filigreed window casings and the airiness of the fleche. (Larry Melander photograph.)

57

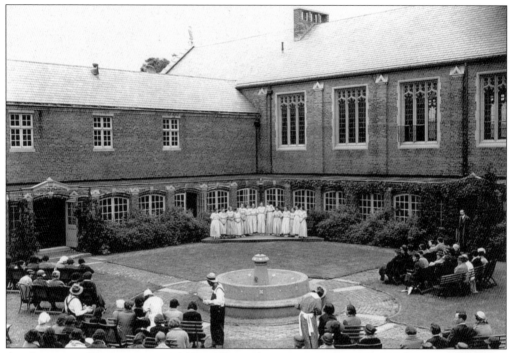

An Outdoor Concert, the 1930s. The girls' music study club performs in the west courtyard of the Howe Building, which was later renamed the Keller-Sullivan Garden.

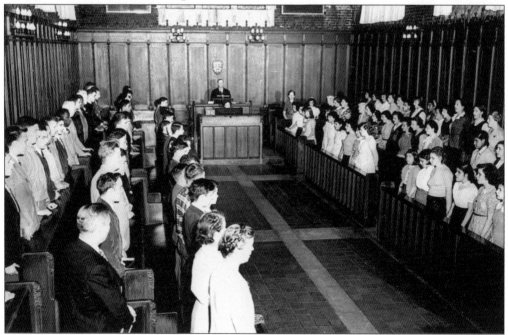

The Perkins Chapel, the 1930s. For decades, the school day started in the chapel with a service of song and morning prayers, often followed by a few inspirational words from the director. Here, director Gabriel Farrell leads upper school students in a hymn. Boys are on the east side of the chapel, and girls are on the west side.

A WARM WELCOME, THE 1960s. Greeting Christmas concertgoers is director Edward Waterhouse, accompanied by his wife, Sina, and her guide dog. The museum in the Howe Building is lavishly decked with Yule greenery, and a handbell ensemble on the mezzanine fills the space with holiday music. The museum area has recently been renovated, with exhibits on the history of Perkins and education for students who are blind.

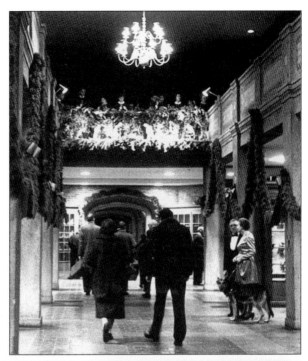

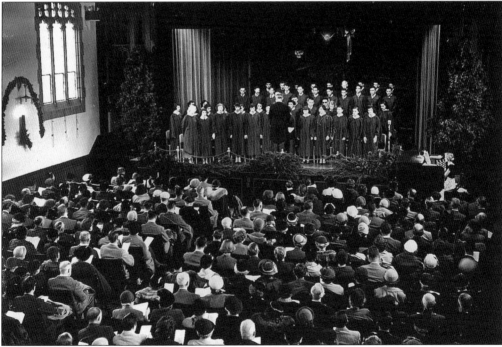

A CHRISTMAS CONCERT, 1952. For generations, Dwight Hall has been the setting for annual Perkins Christmas concerts. John Sullivan Dwight, for whom the hall is named, founded a music journal in 1851 and actively promoted music in the public schools and around Boston. When he became a Perkins trustee, he insisted on including classical music in all students' curriculum and compiled braille music books himself.

59

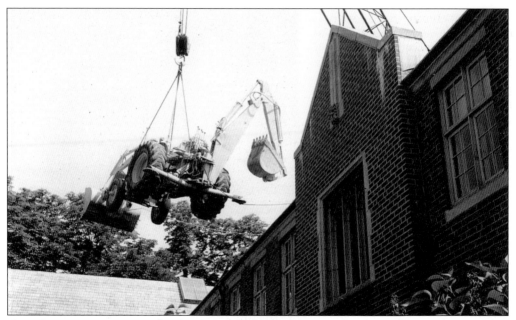

NEW CONSTRUCTION. In 1965, the Samuel P. Hayes Research Library was constructed in the east courtyard of the Howe Building. Large materials and equipment, such as this backhoe, had to be lifted over the building's walls. Perkins psychologist Hayes pioneered psychological testing for children who are blind. After 35 years, the research library was moved to the original library space in the Howe Building. The 1965 building now houses the Development/Public Relations staff and the Hilton/Perkins Program.

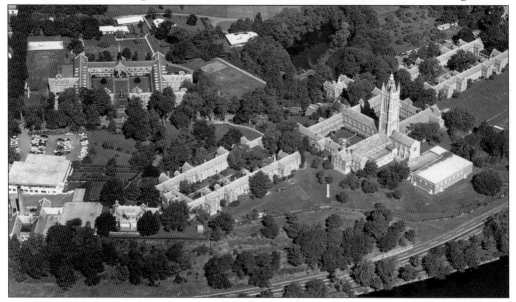

AN AERIAL VIEW OF THE CAMPUS, THE 1960s. This photograph, taken before the construction of the Hilton and Northeast buildings in 1970, shows an excellent view of the Perkins Pond. For decades, students, staff, and neighborhood children enjoyed boating and ice-skating on the pond. Now a lush wooded sanctuary teeming with birds, it has been fenced for safety.

60

THE HILTON BUILDING. The school honored the Hilton Foundation's support of deafblind education at Perkins and worldwide by dedicating the Conrad N. Hilton Building in 1994. It houses the Perkins Deafblind Program, which serves students both on and off campus, and the federally funded New England Center Deafblind Project, which, since 1969, has provided technical assistance to students who are deafblind and their families and educators throughout New England.

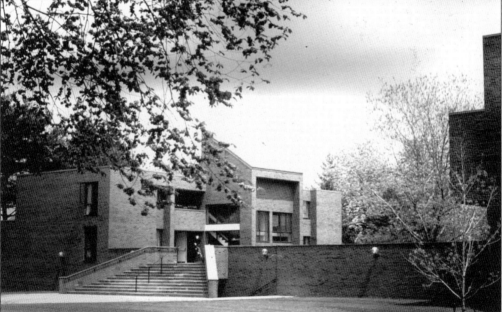

THE NORTHEAST BUILDING. Perkins erected two new buildings in 1970 in preparation for the large numbers of children who were deafblind from the rubella epidemic in the mid-1960s. Part of the Northeast Building, which now houses Preschool Services and Outreach Services, was dedicated as the Donald H. Hubbs Children's Center in 1999 in honor of the head of the Conrad N. Hilton Foundation.

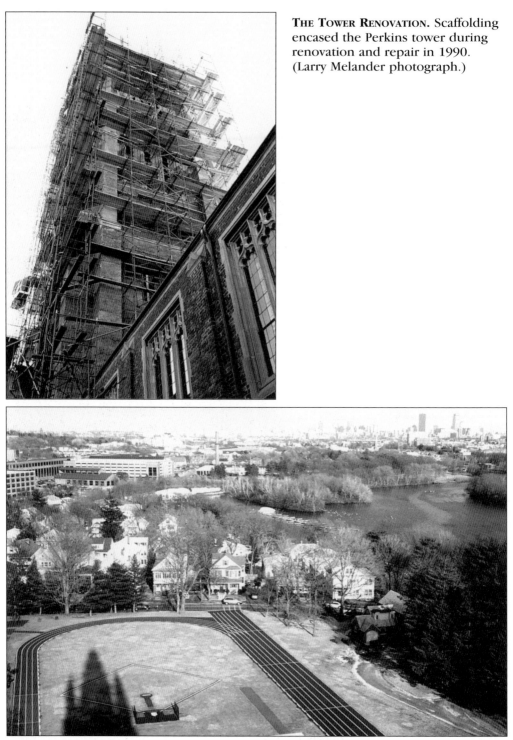

THE TOWER RENOVATION. Scaffolding encased the Perkins tower during renovation and repair in 1990. (Larry Melander photograph.)

A TOWER VIEW. The tower's shadow falls across the running track, with a view of the Charles River, the Watertown Arsenal, and the 2004 Boston skyline in the distance. (Larry Melander photograph.)

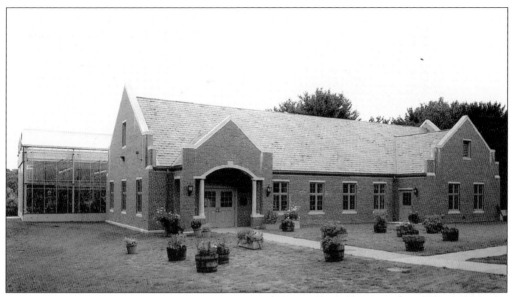

THE THOMAS AND BESSIE PAPPAS HORTICULTURE CENTER. Opened in October 2003, this graceful building is the Perkins campus's newest addition. Designed to harmonize with existing buildings, the Pappas Center uses bricks from the same company that supplied them for the rest of the campus in 1911. The building is heated with efficient geothermal energy. The Pappas family's foundation, based in Belmont, is well known for its philanthropy to educational and Hellenic causes in the area.

AN EDIBLE HOWE BUILDING, 1979. Michael McLaughlin, one of the cottage cooks, created this 300-pound cake in the shape of the Howe Building, complete with tower, for Perkins's 150th anniversary. After marveling at the baker's expertise and creativity, the school's students, staff, and their guests made short work of the confection.

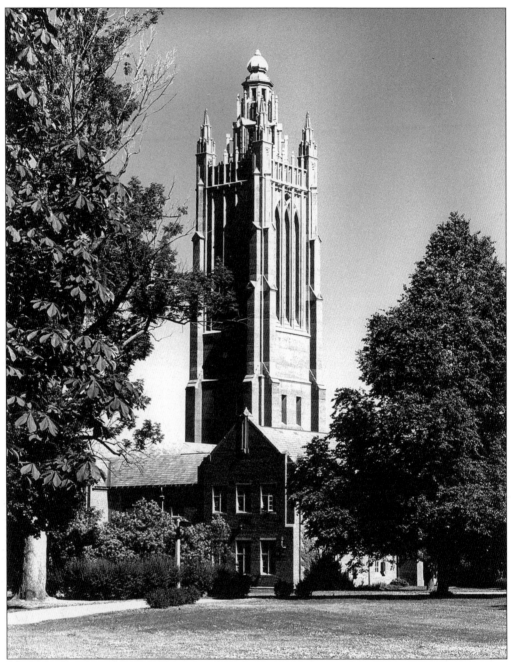

A Timeless Symbol. The Howe Building, with its distinctive tower, is the centerpiece of Perkins's lovely campus, designed under the supervision of director Edward Allen. His experience at the Royal Normal College for the Blind in England and at the Overbrook School for the Blind in Pennsylvania convinced him that a beautiful school environment creates an atmosphere of dignity and respect that is uplifting to all who inhabit it.

Six

CONNECTING THE DOTS

Literacy is the cornerstone of education—both its means and an end. Yet in early-19th-century America, no one considered teaching people who were blind to read and write. Some educators said there was no need, because they could be read to. Samuel Gridley Howe, Perkins's first director, rejected that idea. People who are blind need to be able to "read over a passage . . . reflect on it as long as they choose, and refer to it on any occasion," he wrote.

In early European books for the blind, the standard Roman alphabet characters were raised so they could be felt with the fingers or read by sighted teachers. Howe was distressed by these books' clumsiness, expense, and scarcity. In 1834, he designed an improved raised-type system called Boston Line Type. Each letter's size was reduced. All the descenders, such as *g* and *p*, were raised to make the baseline even. Howe also financed a separate printing department for the new school. Its first publications, on special thin paper, were the Acts of the Apostles, Shakespeare, Milton, poetry, and history books.

Ten years earlier, a 15-year-old student at the Paris school for the blind, Louis Braille, had developed a system using combinations of six dots to represent letters. Most people who were blind found raised type frustrating or impossible to read, and it was impractical for writing. Fellow students loved the new system, but Braille, who became a teacher at the school, never saw wide acceptance of it. His system was unknown in the United States until 1860.

Over the next seven decades, a bitter feud over which reading system was best—dubbed the War of the Dots—raged among educators, most of whom were sighted and did not read any tactile system. After failing to persuade Howe and others to adopt braille, William Bell Wait of the New York Institution for the Blind in the 1860s designed his own system, each cell two dots high and varying from one to four dots wide. It became known as New York Point and was used for 50 years in most U.S. educational books for the blind.

Joel W. Smith, a blind piano-tuning teacher at Perkins, found Braille's original cell size of three dots high and two wide more readable. To make writing easier, he reassigned the fewest dots to the most common letters, such as *a* and *t,* and he introduced contractions for frequent words and letter combinations such as *ing* and *tion*. In 1878, he proposed his Modified braille system, later renamed American braille, to the American Association of Instructors of the Blind (AAIB). Others proposed variations of British braille. All were rejected.

Charles W. Holmes, president of Perkins's alumni association, in 1905 described the resulting chaos: "[W]e have at present five distinct codes of embossed print [that] the blind reader must learn, and keep well up in. . . . Imagine for a moment the ridiculous situation that would arise, if the daily papers published in Boston had an entirely different system of characters from those used by New York publishers, and that a

Philadelphia man could not read either without special training, because his own city had adopted a third, as unlike the others as the Chinese characters are unlike the Roman."

Perkins students used Smith's American braille for their own writing, but Boston Line Type remained the school's standard until 1908, after Edward Allen became director. Allen, with experience at schools for the blind in London and Philadelphia, was the only U.S. educator who knew all the type systems. He has been credited as a singular influence on the eventual adoption of braille in 1918, making the United States one of the last developed countries to do so.

At last people who were blind had a single English code they could read more easily *and* write. Still, early technology—a slate and stylus to punch out each dot—was tedious and difficult to teach to young students.

Howe Press manufactured several models of early Braillewriters, but they were heavy, awkward, and expensive, and needed frequent repair. Gabriel Farrell, who became Perkins's director in 1931, ceased their production.

Farrell learned that a recently hired woodworking teacher, David Abraham, was an excellent machinist and asked him to work on the problem. After emigrating from Liverpool, England, during the Great Depression, Abraham had happened to knock on Perkins's door looking for work. He turned out to be the ideal candidate to take on Farrell's mission.

The new design had to be tough, quiet, accurate, and easy to use. It had to have a light touch and quick paper insertion and line spacing. It had to allow paper reinsertion for corrections and additions. Abraham innovated a lever to keep the finished paper from falling on the floor. For almost a decade he worked alone on the design in his basement in Waltham.

In 1941, Abraham's prototype was ready. With more than 750 parts, it had finer precision than a watch. Wartime manufacturing restrictions postponed production, however. After the war, Perkins administrators took a huge financial risk, spending almost half of the Howe Press endowment to manufacture the first Perkins Braillers, which went to market in 1951. Demand outstripped supply for years.

To date, Howe Press has manufactured nearly 300,000 Perkins Braillers, now the world's standard. Although electronic braille devices and translation software are now available, many people who are blind use a Perkins Brailler as well. They are reliable, simple, and last a lifetime—qualities that also make them ideal for developing countries, which receive many of the machines made today.

In 1978, in order to focus on making Braillers, Howe Press turned over its book production to the National Braille Press in Boston, founded by Perkins graduate Francis Ierardi in the 1920s. Yet the school makes more books available than ever through its lending library, begun in the 1880s. Each year, the Perkins Braille & Talking Book Library circulates more than 500,000 volumes by mail.

Howe's dream of self-sufficiency through literacy is still a perennial mission of Perkins educators. Statistics show that it is possible. While 70 percent of blind people without braille skills in the United States are unemployed, 85 percent of those who are Braille literate have jobs.

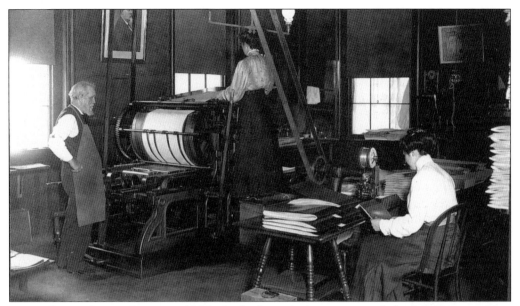

HOWE PRESS, SOUTH BOSTON, 1909. Both the printing press and the binding machine have enormous open drive belts connected to the ceiling. These workers are creating books in American braille, which was developed at Perkins School for the Blind. In the 1930s and 1940s, the Howe Press annual output peaked at more than a million pages of braille, mostly for books for the Library of Congress National Library Service and braille music used at Perkins.

THE 25,000TH PERKINS BRAILLER, 1964. Pictured with the landmark machine are, from left to right, Perkins Brailler inventor David Abraham, Howe Press manager Harry Friedman, and Perkins director Edward Waterhouse. A perfectionist and mechanical wizard, Abraham several times each year shut down Brailler production for a week, whenever he discovered a part not made to his standards.

LEARNING TO WRITE, THE 1950s. The Perkins Brailler considerably sped up the writing process for people who are blind. A braille slate requires the user to punch each dot individually by hand through the back of the paper. The mechanical Brailler produces each braille cell, three dots high and two wide, with a single movement. The Perkins Brailler is an invaluable teaching tool because it produces text that can be instantly reviewed as it is created.

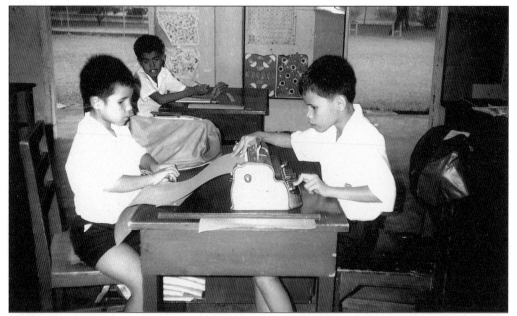

A PERKINS BRAILLER IN THAILAND. Reliable, simple, and durable, Perkins Braillers are ideal for use in developing countries. Almost entirely metal, they hold up to dust, humidity, and heavy use, and require no electricity and little servicing. The Hilton/Perkins Program, funded by the Conrad N. Hilton Foundation, has donated and subsidized Braillers throughout Africa, Asia, Latin America, and Eastern Europe.

HOWE PRESS, THE 1950s. Equipment has been modernized, but otherwise the Howe Press shop looks much the same today. In the 1990s, Perkins helped establish Brailler assembly factories in India and South Africa—both employing workers with disabilities and reducing the cost of the machines in those regions.

THAT ALL MAY READ. . . .
This little one's love of a good Talking Book story is creating a foundation for literacy. The 18,000 patrons of the Perkins Braille & Talking Book Library range in age from 7 months to 113 years. The library collection includes 75,000 titles on audiocassette or in braille and is available to all whose disabilities prevent them from reading print material.

IMPROVING TECHNOLOGY. This library patron is listening to a Talking Book cassette player. In the background is the now phased-out record player. The Library of Congress has been developing a less expensive and more durable digital format for Talking Books, using lighter and more portable equipment. Within a few years, the new technology should be available to patrons of the Perkins Braille & Talking Book Library.

KEEPING THE WHEELS TURNING. Volunteers are indispensable to the school's many activities—nowhere more so than at the Perkins Braille & Talking Book Library. The library sends and receives 2,300 volumes per day, and volunteers check in returned books, rewind tapes, and help in the mailroom. A team of trained volunteers records books of local interest in the library's state-of-the-art studio.

Seven

TOUCH THE WORLD

Helen Keller's biggest disappointment was that she never learned to speak clearly. For the past century, educators of children who are deafblind have been absorbed with the question of the best way to teach them to communicate.

At the beginning of the 20th century, a debate arose over whether students who were deafblind were better served at schools for the deaf. Teachers of both, some said, shared the primary task of breaking through children's isolation and giving them a means to communicate. Yet Perkins, the pioneer of the communication methods used by Laura Bridgman, Annie Sullivan, and Helen Keller, continued to draw many students who were deafblind—increasingly from around the country. They attended the regular Perkins program, and they each also had a personal teacher who always accompanied them.

In 1932, teacher Inis Hall organized the country's first program specifically for students who were deafblind. Hall had previously taught at the South Dakota School for the Deaf, where she had learned a method for teaching speech, developed by fellow teacher Sophia Alcorn *c.* 1910. Alcorn had her students place their hands on her jaw and their thumbs over her lips to feel the movements and vibrations as she spoke. Then, she had them place their hands on their own face and try to duplicate those sensations. Students learned both to produce speech and to comprehend it by feeling a speaker's face. The technique became known as the Tadoma method, after Alcorn's first students, Tad Chapman and Oma Simpson.

Hall, who brought Chapman with her to Perkins, modified and greatly expanded the use of the Tadoma method in the 1930s and 1940s. Teachers came from around the world to learn it. The results were remarkable—pleasant-sounding, fluent speech and the ability to converse freely with any English speaker. Many Perkins students went on to lead successful, independent lives, such as Robert Smithdas, the first deafblind person to earn a master's degree, who now serves as community-education director at the Helen Keller National Center for Deafblind Youths and Adults in Sands Point, New York.

Acquiring speech was not easy for student or teacher. Speech took much longer than all other forms of communication, which, at the time, were discouraged until students mastered speech. The key was unfailingly patient repetition—hour after hour, day after day. For even the most exceptional students, the process took years, and many could never learn Tadoma. Students who showed no progress within a year or so were dismissed.

At the same time, flaws in the one-on-one teacher-student relationship became more obvious, as though "teacher and child were tied in some sort of knot," as one educator put it. Creating a dependence on one person at school was not good preparation for independent living, and it demanded an unhealthy sacrifice of personal life from teachers. In the mid-1930s, the Deafblind Program assigned each teacher two students to instruct, and an attendant was responsible for them outside the classroom.

During World War II, teachers were in short supply and the program faltered. In 1956, Perkins and Boston University started the first graduate program for teachers of

deafblind children in the world (now at Boston College). Six of the first nine trainees joined Perkins's staff.

In the 1960s, a maternal rubella epidemic increased the number of children identified as deafblind in the country from 300 to nearly 7,000 within a few years. The population of children who were deafblind became much more diverse, in cause and ability. Many children with congenital rubella syndrome also had a range of motor and cognitive disabilities, and premature children were usually even more severely disabled. Most of these children could not learn speech. At the same time, the Deaf community began to argue that speech is an unnatural means of communication for them. Tadoma became much less used.

No single teaching method worked for all, and information about the new cases of deafblindness was not readily available. In 1983, Perkins teachers compiled nearly 800 pages of articles in two volumes, focusing on how to teach language to deafblind children. A godsend to educators and parents, the book covered many little-addressed topics, such as how to teach deaf children losing vision or congenitally deafblind children.

Jan van Dijk, a graduate of Perkins's teacher training program and a professor for the past 40 years at the Netherlands's Viataal (formerly the Instituut voor Doven), broke new ground studying the stage just before children begin to express themselves—a stage that children with multiple disabilities may stay in for years. Van Dijk and colleagues introduced numerous strategies that Perkins educators have adapted and used widely to reach children with multiple disabilities, who are often so withdrawn that capturing their interest is difficult. In one technique, teachers move with children in their favorite activities, such as rocking or jumping. Coactive movement teaches children they can influence their environment and interact with it—an initial step toward communication.

Today, the philosophy of the Perkins Deafblind Program is total communication—using speech, signing, fingerspelling, natural gestures, pictograms, or any means in any combination that works for a child. Contrary to previous thought, research has shown that learning any kind of communication will aid, not inhibit, acquiring other forms. Prematurity is currently the leading cause of deafblindness in students within the program. Most students served on campus have multiple disabilities. More than a quarter of them have CHARGE syndrome, a recently identified complex of birth defects that may also include heart, gastrointestinal, cognitive, and other disorders.

Helen Keller may always be the best-known deafblind success story. Yet in the past century, hundreds of children who are deafblind have quietly but just as remarkably triumphed over their disabilities through education. Numerous Perkins graduates who are deafblind have gone on to further education, jobs, and independent- and supported-living situations. They work in rehabilitation, education, business, technology, fund-raising, motivational speaking, manufacturing, and food and health services. They marry and have families, own homes, entertain friends, and contribute to their communities and families. Just as Helen Keller did, through their achievements and interactions with others, they inspire the worlds they touch.

HELEN KELLER'S CLASSMATES. Perkins has been educating children who are deafblind since its beginnings. Helen Keller (left), the school's most famous student, poses with fellow Perkins deafblind students Elizabeth Robin, Edith Thomas, and Tommy Stringer. At age 10, Keller organized a fund-raising drive for the education and support of penniless Tommy Stringer, her first instance of activism in a long life spent working for those disadvantaged by disabilities and poverty.

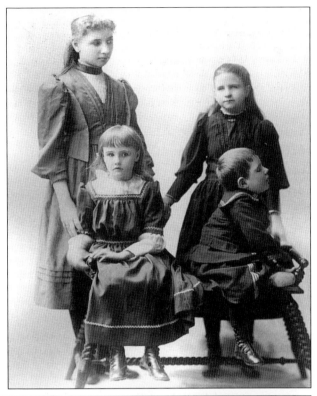

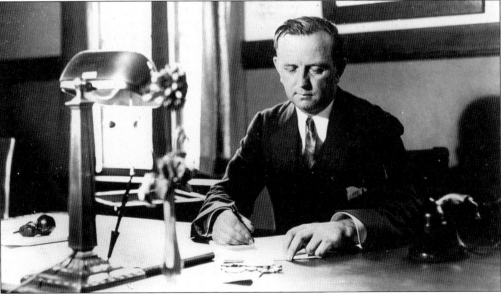

GABRIEL FARRELL, PERKINS'S FOURTH DIRECTOR, 1931–1951. Under Farrell's leadership, Perkins created the country's first program specifically for students who are deafblind. Farrell also ended the separation of classes for male and female students, started publication of *The Lantern*, established the school's pension plan, and laid a sound foundation for the school's financial management. He was also active in international organizations dedicated to the education of the blind. (Nelson Coon photograph.)

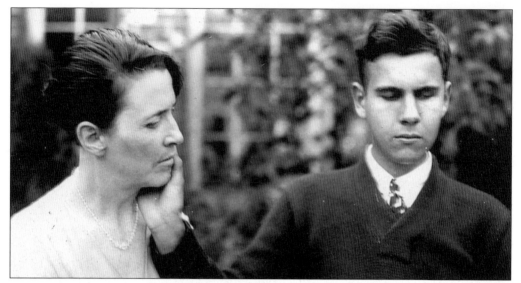

INIS HALL AND TAD CHAPMAN, 1934. When she was hired at Perkins, Inis Hall brought her student Tad Chapman from the South Dakota School for the Deaf. Shown here reading his teacher's speech, Chapman is one of the two students for whom the Tadoma method of tactile lipreading is named. Throughout his life, he enjoyed woodworking, knitting, and gardening, all of which he learned at Perkins. (Nelson Coon photograph.)

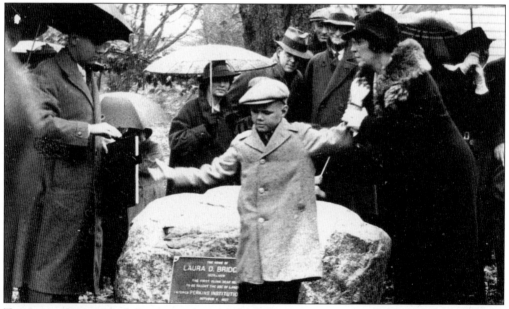

THE LAURA BRIDGMAN CENTENNIAL. On October 20, 1937, students of the Perkins Deafblind Department commemorated the centennial of Laura Bridgman's arrival at the school by unveiling a plaque, which can still be found at her family home near Hanover, New Hampshire. In the foreground are Leonard Dowdy, a Perkins student who was deafblind, and teacher Inis Hall. Dowdy, who later married and worked in manufacturing, gave a speech at the 1966 Annie Sullivan Centennial that inspired Pres. Lyndon B. Johnson's administration to establish Regional Centers for Deafblind Services.

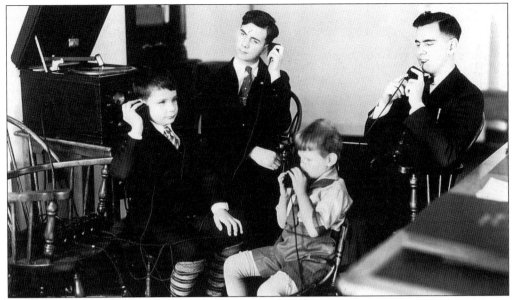

THE PHIPPS UNIT, 1934. This apparatus enabled people who were deaf or deafblind to understand speech and music through a microphone and speaker. These students are feeling sound vibrations in their head bones and teeth. Although used extensively by Perkins teachers and students in the 1930s, the Phipps Unit never gained widespread popularity.

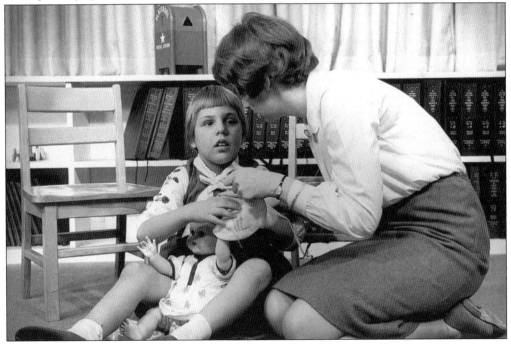

LEARNING ABOUT CLOTHING, THE EARLY 1960s. This student's teacher gets down on the floor to work with her. Successful teachers of children who are deafblind first uncover how their students understand the world and then figure out which combination of teaching techniques works for each individual child. (Courtesy Campbell Films.)

TALKING TO THE COACH, THE 1960s. This student, who is deafblind, pauses in her exercise program to get some instruction on her swimming technique. The high ledge around the pool prevents students from accidentally falling in.

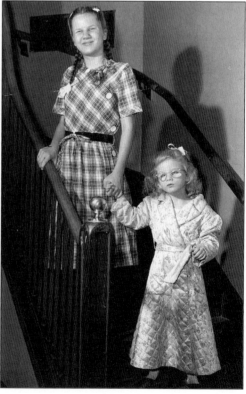

SCHOOLMATES, THE 1950s. These two girls in the Perkins Deafblind Department share a moment of sisterlike tenderness.

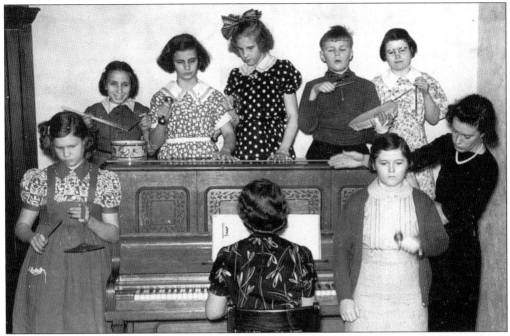

A Rhythm Band, 1939. Auditory training helps students who are deafblind discriminate among the vibrations made by different objects and people. The sequencing and rhythm of music is also helpful in learning to communicate.

Total Communication. This student is congenitally deafblind as a result of the maternal rubella epidemic of the mid-1960s. He has some usable vision, which helps him communicate with his teacher in American Sign Language.

CHILD-CENTERED EDUCATION. Because every student who is deafblind has different needs and abilities, this field of education requires that teaching techniques be tailored to the individual child. Contemporary causes of deafblindness are extreme prematurity and birth defect syndromes, often resulting in multiple disabilities. Education of children who are deafblind demands great commitment and intensive presence of mind and heart. (Carol Benoit photograph.)

SPREADING THE WORD. Alumna Jaimi Lard, deafblind since birth, has been a dynamic member of the Perkins public relations team since 2001. As a school spokesperson, Lard makes presentations through an interpreter to schools and civic organizations, emphasizing the necessity of education for all people and the importance of communication. Lard (right) uses tactile sign language to converse with a youngster.

Eight
LIFE AT PERKINS

The lifeblood coursing through Perkins is the students who come to learn and the staff members who dedicate themselves to their education and care.

Since its beginnings, Perkins has had full days. Samuel Gridley Howe instituted a round-the-clock regimen. Students were awakened at 5:30 a.m. Roll call was taken at 6:00 a.m. Study began at 6:30 a.m. and continued until 6:00 p.m., with time out for meals, rest, and exercise in the fresh air, which in the summer included ocean swimming in South Boston. Reading time followed dinner. Bedtime was at 10:00 p.m.

Permeating all of life at Perkins is the sound of music, in the classroom and out. From the beginning, music was considered as essential as academics and manual arts, and the early schedule allowed four hours daily for lessons and practice. Thus, music has always been everywhere at the school. The sounds of students practicing voice, piano, organ, guitar, and drums ring out in the performance halls and classrooms, and jam sessions and spontaneous outbreaks of song fill the cottages, closes, and playing fields.

A service of songs also began each day, continuing through the 1970s. The chorus's chapel anthems and group hymns are still sung at alumni weekends. Each morning students lined the hall to the chapel, waiting for the director, and then filed in to their seats—boys on the east, girls on the west. Attendance was taken, and then the director read from Howe's original Bible, made the day's announcements, and gave a chapel talk. Local religious leaders came to the school on Thursday afternoons to teach religious education classes.

Student life has centered on the cottages, where students and staff live together in groups resembling families. Howe envisioned the cottage plan decades before it became common at schools for the blind. Because of cost and space, however, Perkins built cottages in South Boston only for girls. Not until 1912 was Edward Allen able to realize Howe's dream fully at the new campus in Watertown.

Still today, each of the school's 12 cottages has its own dining, living, and sleeping rooms. Students have cottage cleaning and kitchen chores. Perkins staff members serve as houseparents, eating and living among the students. The arrangement helps students learn to adapt to many kinds of people. Some houseparents have been young, and others have been older; some have been single, and others have had families with children and pets; some have been teacher trainees from foreign countries. The friendships forged by living together in small groups, among staff and students alike, are typically close and lifelong.

Throughout the school's history, another fundamental of Perkins life has been exercise and recreation. Students have played and excelled in just about every sport—football, basketball, baseball, track, swimming, archery, bowling—with cottage teams competing year-round. Some sports and some students require adaptations; some do not. In 1940, Perkins organized a wrestling team, which for years competed fiercely with sighted students at local private schools. To be Perkins's top wrestler was a

coveted honor. A favorite current game is goalball, in which teams of three try to move a ball with a bell inside it past the opponent's goal line. Until the early 1980s, students enjoyed boating and skating on Perkins Pond, now fenced for safety. Clubs of every interest have thrived, among the most popular ham radio, chess, and scouting.

Perkins has always made much of holidays, which are times many alumni most remember—hunting for chirping Easter eggs specially made by the Telephone Pioneers of America, dancing around a Maypole, smelling the evergreen trees that announce the Christmas season. One favorite holiday observance is uniquely Perkins's: Stephen Blaisdell, a student in the mid-19th century, always wished he had spending money. He went on to succeed in business, selling pianos and sewing machines. When he died in 1901, he left a $10,000 fund—all for students. Each year on Lincoln's Birthday, Perkins students still receive Blaisdell dollars to spend as they wish.

As at many residential schools, the list of school rules has often seemed endless. Rules covered dress, punctuality for classes and meals, hours that students could or could not be in the cottages and classrooms, places they could go on and off campus, the number of cups of coffee or tea they could have, and on and on.

The rule most remembered at Perkins—and unquestionably most broken—was the segregation of the sexes. During the school's first century, boys and girls were not allowed any contact with each other, and all facilities were kept separate. Then, in 1936, Perkins began coeducational classes. Still, due to concern that blindness could be passed on genetically, boys and girls were forbidden to speak or meet outside class. Boys from other local private schools were invited to Perkins girls' dances, and vice versa. The restriction was later lifted, but people who remember those days say with a smile, "If these walls could talk. . . ."

The fun of pranks remains fresh in the memories of many alumni: stealing apples from the orchard and then shaking the tree to rain fruit on pursuers; stamping in Morse code at dinner; climbing the pine trees. In the early 20th century, boys raised chickens for eggs and had to take turns waking early to feed them. A repeated trick was to set the alarm clock of the student on duty an hour earlier.

Over the years, several people have passed through Perkins on their way to fame. After bringing to the school a Syrian boy blinded in an explosion, aviatrix Amelia Earhart volunteered each week, reading to students and helping with drama. Henry David Thoreau unsuccessfully applied to teach. The first woman photojournalist, Margaret Bourke-White, whose mother was Perkins's first nutritionist, took a series of campus photographs in the 1930s. Joan Baez, who sang and played guitar with students, was a houseparent in Oliver Cottage briefly in 1959. For years, Perkins students sat in front whenever Baez gave concerts in the area, and she often came down to talk with them.

Today, students explore nearby communities on field trips; off-campus vocational jobs; visits to local restaurants, malls, and theatrical and educational events; and many other outings. In the 21st century, life at Perkins extends well beyond the campus.

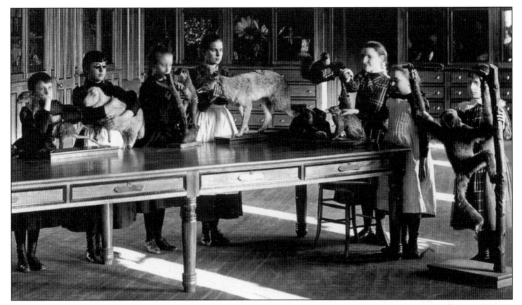

A Tactile Museum, 1893. Learning about the world through the sense of touch has always been part of the Perkins curriculum. The tactile museum included mounted animals, shells, rocks, and minerals; artifacts from different cultures; and models of bridges, buildings, vehicles, and human anatomy. Today, Perkins teachers still use these tactile items, many used by students for more than 100 years, in their classrooms.

A Physics Experiment, 1926. Two students spin a huge wheel and test the resistance created by the weight of sandbags. (H. E. Towle photograph.)

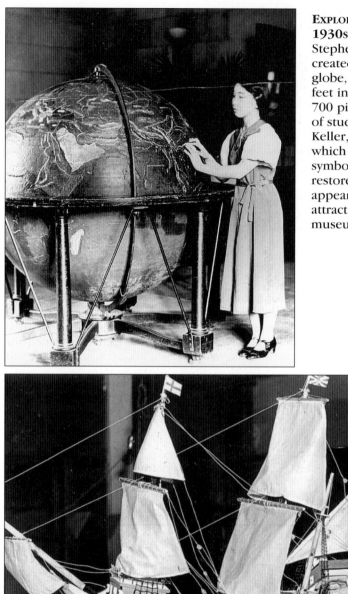

EXPLORING THE WORLD, THE 1930s. The school's printer, Stephen P. Ruggles, in 1837 created Perkins's unique tactile globe, which is more than four feet in diameter and made of 700 pieces of wood. Generations of students, including Helen Keller, have used the globe, which has become a beloved symbol of Perkins. Recently restored to its original appearance, it is a central attraction in the renovated museum area.

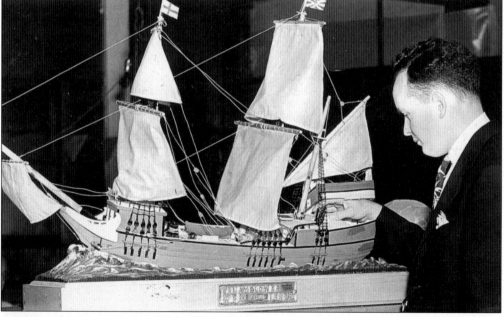

A MODEL STUDENT. In the 1930s, Work Projects Administration laborers, cosponsored by Perkins and the Massachusetts Commission for the Blind, built detailed models for the school, including bridges, a log cabin, houses, and tactile mathematical illustrations. This young man is exploring the *Mayflower*. Portions of the deck were removable so the interior could be examined. Some of these beautiful models are still in use at Perkins.

THE PERKINS LIBRARY, 1904. The school's original library today has three descendants: the Secondary Program Library for students, the Samuel P. Hayes Research Library for educators and researchers, and the Perkins Braille & Talking Book Library, which serves 18,000 people throughout New England. (J. H. Mabey photograph.)

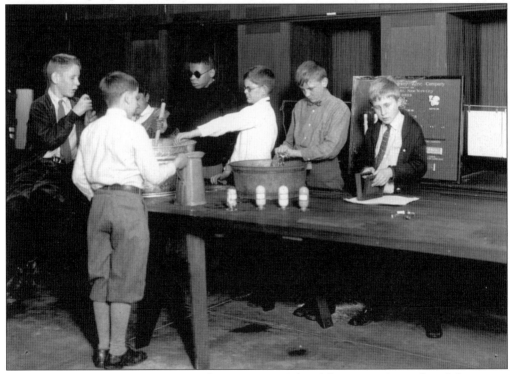

A CHEMISTRY EXPERIMENT, 1929. These Lower School boys are intently mixing up a concoction in galvanized buckets, with pitchers and egg beaters close at hand.

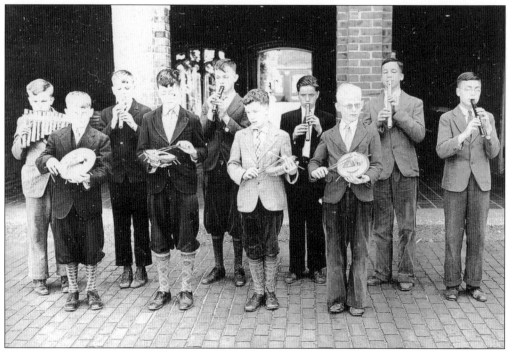

A 10-Piece Band, the 1920s. Framed by the archways of the Lower School, these boys are performing a musical piece. The Perkins music program was well known for its excellence. Schools for the blind in other states often sent their most promising music students to Perkins for advanced training.

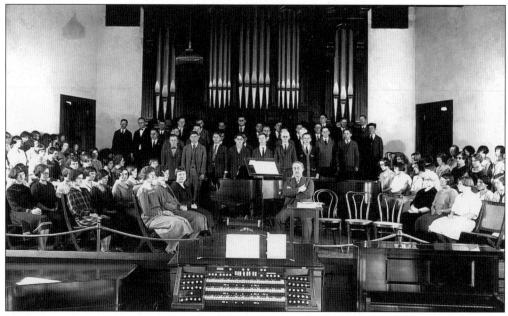

The Upper School Choir, 1925. With about 60 voices, the Perkins choir could produce a very rich sound. (Dodman photograph.)

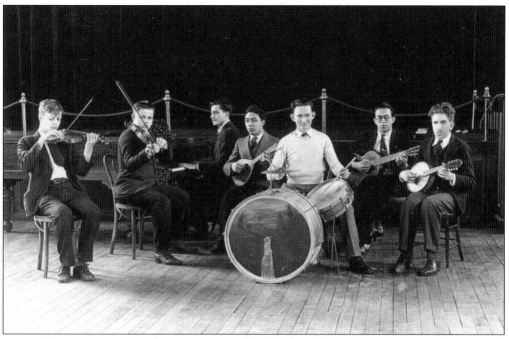

SWING TIME, THE 1930S. This seven-piece combo has the instrumentation of a country swing band: two fiddles, a guitar, a banjo, a mandolin, keyboards, and a drum kit. Unlike the stiffly posed musicians in long-exposure 19th-century photographs, these boys are shown moving and having some fun with their instruments.

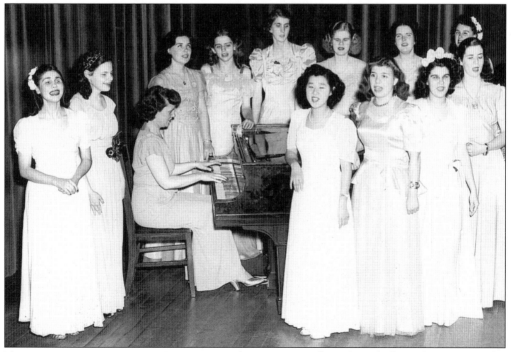

THE YOUNG WOMEN'S GLEE CLUB, THE 1940S. Wearing floor-length formals, these joyful singers gather around the grand piano.

READING MUSIC. This young pianist reads her braille score with one hand and plays her instrument with the other. Louis Braille, the inventor of the international writing system for people who are blind, was also a church organist. In addition to his writing code, he developed the music braille system. The Perkins Archives include the Bettye Krolick International Music Braille Collection, for studying the history of music codes. (John Kennard photograph.)

NEVER TOO YOUNG. This young girl is tooting her horn, enjoying the change in tone when she passes her hand in front of the horn's bell. Such play provides important lessons in differentiating sounds and vibrations.

An Advertisement for Piano Tuning, 1889. For most of its history, Perkins had an excellent piano-tuning department. Perkins tuning students serviced all the pianos in the Boston public schools for more than 50 years. Many Perkins-trained tuners are still active in the profession.

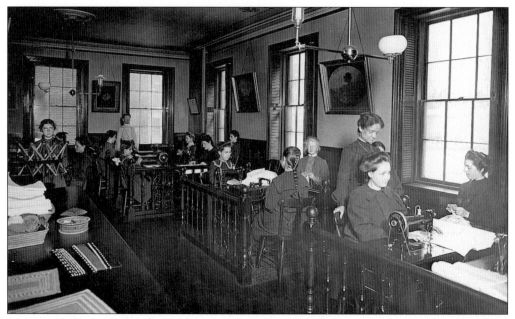

A Sewing Class, 1909. Domestic and vocational skills have always been part of the Perkins curriculum. Seated at treadle sewing machines, students are working with lengths of white fabric. In that era, students made all the school's linens. On the left, a student is spinning an umbrella swift, used to wind skeins of knitting yarn into balls.

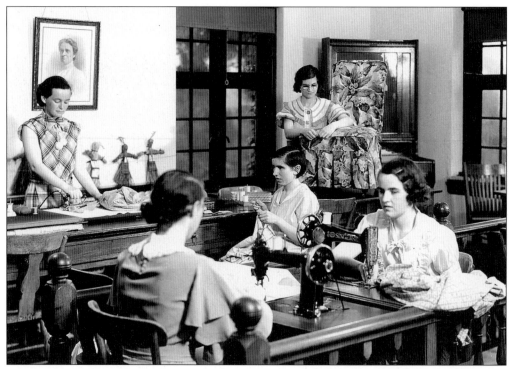

A Sewing Class, the 1930s. Textile arts continued to be a popular subject for generations. These girls are learning professional upholstery skills.

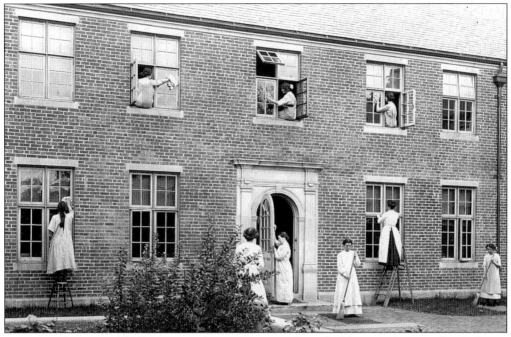

WINDOW WASHING, 1916. Two young women perch on ladders as they scrub windows, and several others lean out of the second story. Bennett Cottage, named after longtime girls' principal Gazella Bennett, was designed to teach girls housekeeping, which seems quaint now. In the past, however, domestic skills were considered important for independence and vocational preparedness. Today, the cottage has an apartment to prepare students of both sexes for independent living.

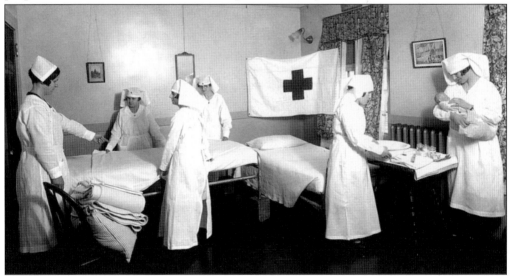

A HOME NURSING CLASS, 1926. Decked out in white nurses' uniforms and starched caps, several young women learn sheet changing, while two others practice infant care with a baby doll. A Red Cross instructor taught this extremely popular class, which included nutrition, disease prevention, and caring for convalescents, infants, and small children. (Henry E. Towle photograph.)

A Typing Class, the 1930s. The vocational curriculum changed over the decades to incorporate new technologies. Here, five young men learn to type, a skill useful for college and business. Perkins teacher Joel Smith introduced touch-typing to help people who were blind learn the typewriter. Only later was it adopted by sighted typists.

An Anatomy Class, 1936. This young woman is examining the shoulder structure of a human skeleton. Her massage therapy coursework requires an understanding of the human muscular system, right down to the underlying framework. Throughout history, massage therapy has been a chosen profession for many people who are blind. For many centuries in Japan, massage practitioners were almost exclusively blind.

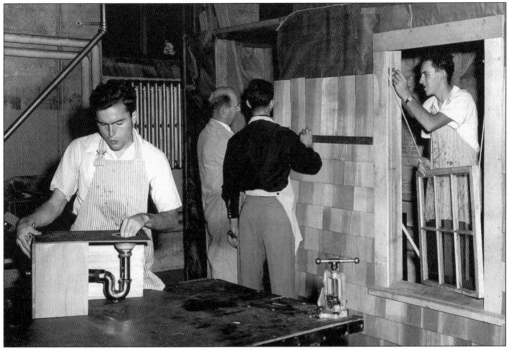

BUILDING SKILLS, THE 1950s. The Perkins curriculum has always included skills that will help graduates support themselves. These boys are learning how to hang windows, apply siding shingles, and install plumbing fixtures.

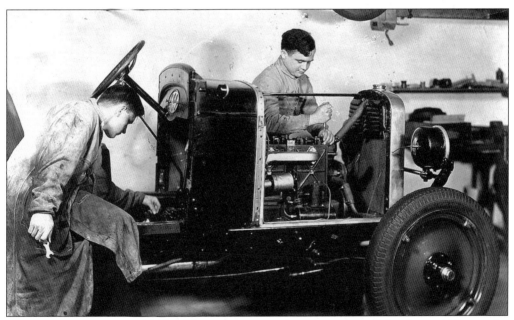

AUTO MECHANICS, THE 1940s. These young men are engrossed in the workings of a Model T automobile. Small engine repair and auto mechanics were popular classes for decades.

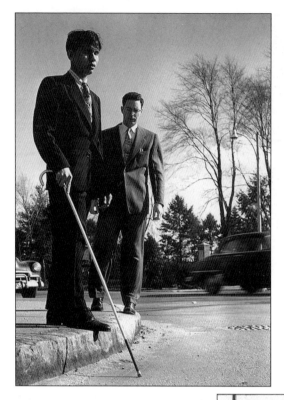

Navigating the Neighborhood, the 1950s. This young man is using his orientation and mobility skills to explore the neighborhood beyond Perkins. Orientation and mobility was developed after World War II, when soldiers returned to civilian life with visual impairments and insisted on learning to move about independently.

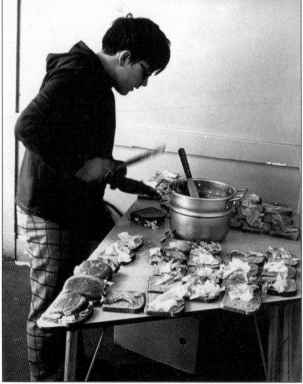

Making Lunch. Perkins's dream for all its students is maximum independence. For some this means college and career. For others it is grounding in independent living skills. Wielding his butter knife with a flourish, this young man is learning the basics of preparing food for a crowd. Today's menu: sandwiches. (Larry Melander photograph.)

A Shakespearean Drama, 1912. Perkins students have always had a rich selection of extracurricular activities to choose from. Here, in a production of *Twelfth Night,* actors in capes and plumed hats cross swords.

Modern Dance, 1926. With their expressive poses and flowing togalike garments, these three dancers evoke the influence of Isadora Duncan in a piece called "Dream Dance."

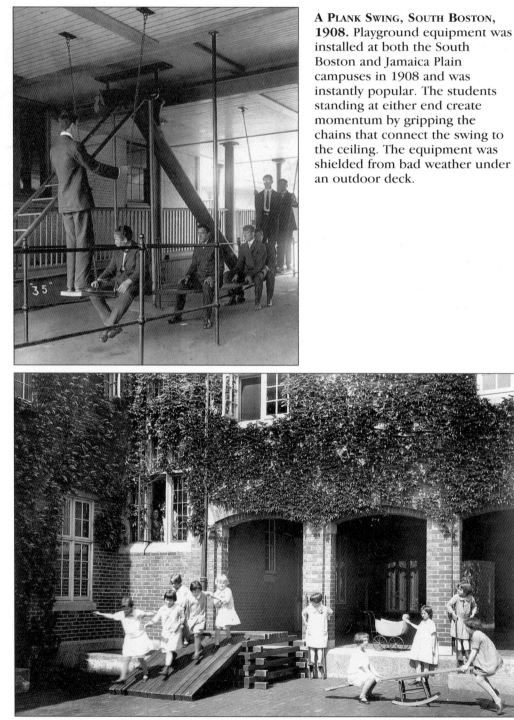

A PLANK SWING, SOUTH BOSTON, 1908. Playground equipment was installed at both the South Boston and Jamaica Plain campuses in 1908 and was instantly popular. The students standing at either end create momentum by gripping the chains that connect the swing to the ceiling. The equipment was shielded from bad weather under an outdoor deck.

BRADLEE COTTAGE GIRLS, 1928. Two girls play on a portable seesaw, while others walk on stilts. Several children are exuberantly running down an incline of planks. In the winter, the slope was used for sledding. The cottage was named after benefactor Helen Curtis Bradlee. (Henry E. Towle photograph.)

Jumbo Lincoln Logs, 1923. In 1920, a high iron fence was built around the campus, and the old wooden fence posts were given to the Lower School boys to play with. Several students in this photograph have created seesaws. At the right, a dozen boys climb on a neatly constructed log cabin. The structure was dismantled and reassembled in a new location several times a week. (Lila J. Perry photograph.)

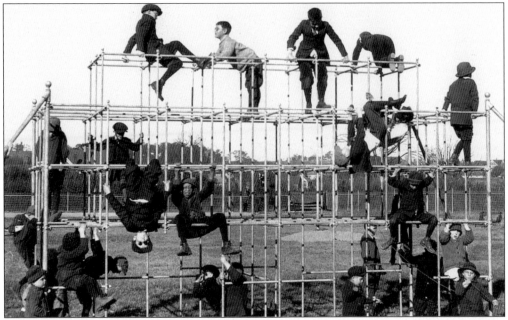

THE JUNGLE GYM, THE 1920S. Two dozen Lower School boys enjoy a five-tier climbing gym. The boys on the top rungs are nearly 10 feet above the ground. One daring student hangs by his knees.

MAY COTTAGE ATHLETIC TEAM, FALL 1935. The girls' uniforms, with baggy bloomers and elaborate bows, must have increased wind resistance considerably. Competitions throughout the year included field meets, cottage songs, waltzing, posture contests, and Stunt Night. The victorious cottage team proudly displayed a winner's banner in its living room. The tiny Lower School cowboy in front is likely the team mascot. The girls' cottage was named after early Perkins Corporation trustee and president Samuel May, great-uncle of Louisa May Alcott.

UPPER SCHOOL SPRINTERS, THE **1940s.** These racers are probably training for a track meet. Three of the runners are using the guide wires to stay in their lanes. Track and field and goalball are now the school's main competitive sports with other schools for the blind.

HUMAN PYRAMIDS, **1931.** Gymnasts display five impressive formations in Dwight Hall.

THE ROCKING BOAT, THE 1950s. This playground attraction was highly popular for decades. The little girls at either end of the boat are enjoying the dramatic rocking from almost ground level to a height of six feet.

ROLLER-SKATING, THE 1960s. These skaters are enjoying the smooth surface of the new gymnasium, built in 1961. Other young people's groups from the community often joined Perkins students for weekend roller-skating parties.

LOW-VISION SOFTBALL. This young slugger is aiming to knock the ball out of the park. Students with low vision use a soccer ball. For batters who are blind, the pitcher bounces the ball a few feet in front of the plate, and the sound cues the student to start his swing.

A TRACK AND FIELD MEET. This young racer gives her all in the event.

A YOUNG RADIO HAM, THE 1920s. This young man is exploring the world with a ham radio set. In the radio shack in the Bridgman Cottage basement, the radio station, established in 1921, was a popular hobby for decades. The Perkins Ham Radio Club had a collection of postcards with call signs of the senders from all over the world.

GIRL SCOUT ATTIRE, THE 1920s. These young ladies are in full Girl Scout regalia, including stylish, close-fitting hats. The Perkins Scout troop is still going strong.

A BOY SCOUT IGLOO, 1971. Perkins Boy Scouts cooked a dinner of buffalo burgers and spent the night in an igloo they constructed in front of the Howe Building. Judging from the troop's bedraggled look, this photograph must have been taken the morning after the overnight adventure.

A WORLD WAR II NEWSPAPER DRIVE. The Perkins community pitched in with the rest of the country with home-front activities to support the war effort. These girls are bundling newspapers for a paper drive. Knitting hats and socks for soldiers was another popular contribution during both world wars.

A Picnic at Revere Beach, 1931. Field trips have always expanded the classroom for Perkins students. Modestly attired in light cotton garments, these barefoot girls yield to the universal impulse to dig a hole in the sand.

The Perkins Choir Tour, 1980. The choir took its show on the road to New York and New Jersey for performances in May 1980. Here, singers are performing in St. Patrick's Cathedral in New York City.

THE SENIOR CLASS TRIP, 1982. Every year Perkins seniors select a destination for their class trip and, for months prior, raise money for it. Perkins students and staff pose on the Capitol steps in Washington, D.C., with House Speaker Tip O'Neill of Massachusetts (second from the left).

THE BUTTONBUSH TRAIL. This Cape Cod trail, which has guide ropes and both braille and large-print signs, delights all the senses. The destination is a favorite with Perkins students and instructors. (Larry Melander photograph.)

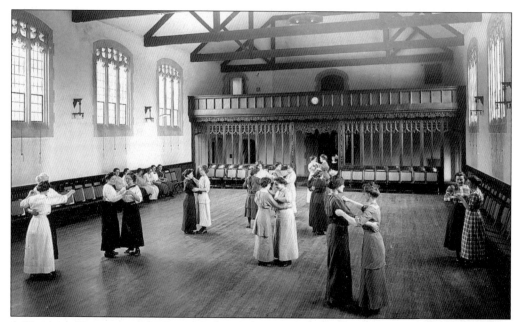

A Monthly Dance, c. 1915. Until the mid-1930s, the education and social life of boys and girls were entirely separate. Each school held its own monthly social dance, with dance competitions among the cottages. Here, the couples waltzing in Dwight Hall are all older girls in upswept hairstyles and Edwardian dresses.

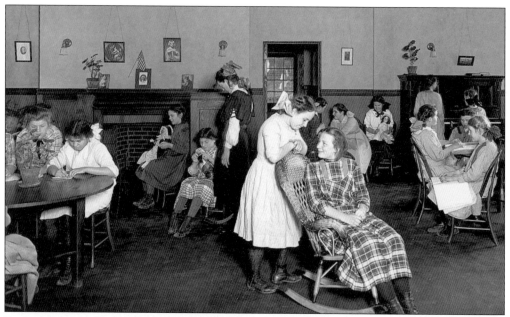

Lower School Free Time, 1914. Activities include knitting, piano playing, singing, playing with dolls, reading, chatting, and writing letters home. The cottage system groups students of different ages, creating a family feeling and encouraging the students to cooperate with one another. (H. F. Albright photograph.)

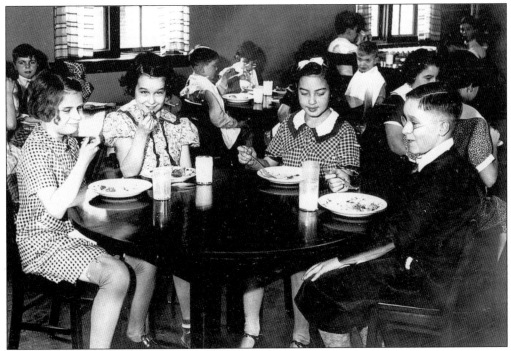

A Cottage Dining Room, the 1930s. These Lower School students enjoy a meal together. The small tables are an integral part of the family-like atmosphere fostered at Perkins. The intimate scale of student life encourages close, often lifelong friendships.

Tactile Chess, the 1930s. These chess pieces are easily identified by touch. A kibitzing friend looks on.

RADIO DAYS, THE 1940s. Enjoying programs together was a favorite pastime during the middle of the 20th century.

CLOSE FRIENDS, THE 1950s. The retaining walls that run along both sides of the West Close have been perfect for socializing since they were built in 1912, originally along brick walks. These girls are enjoying the brilliant spring sunshine in front of Fisher Cottage. A similar group of students can still be found sitting on the wall on any pleasant day.

SANTA VISITS A COTTAGE, THE 1950S. The excitement and pandemonium of the holidays come to Perkins cottages, just as at other homes where children live. In this photograph, Santa Claus has just brought presents to some Lower School students. His harried expression may reveal his regret for having selected so many whistles as gifts.

A ROBUST SQUARE DANCE, 1950. The social world of Perkins is as important as the academic environment. Old classmates eagerly await Alumni Weekend each June as a time to catch up on one another's news.

The Perkins Teaching Staff, 1914. Only 9 of the 48 teachers are men. For decades female teachers far outnumbered males, who usually left when they married. During both world wars, the shortage of male teachers made it necessary to close one of the campus cottages. (H. F. Albright photograph.)

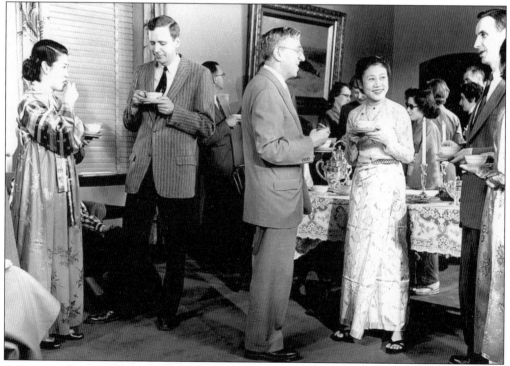

A Formal Tea, the Late 1950s. For many years, staff teas were monthly social events. This reception is in honor of the international teacher training class. Director Edward Waterhouse (center), who was reared in England, demonstrates how to circulate while balancing a delicate china teacup and a biscuit.

Nine

CHANGING TIMES

In the mid-20th century, rapid medical developments and special-education reforms converged in a way that radically transformed Perkins. The school has always taught students with a wide range of abilities, needs, and goals. Between the 1950s and 1970s, however, its mix of students tipped first to one extreme and then just as quickly to another. Perkins had to change fast or risk obsolescence.

Before mid-century, a principal cause of childhood blindness was infectious disease—such as trachoma, high fevers, and maternal venereal disease. Many of the children who survived had blindness as their only disability. They mainly needed a solid academic education, along with skills for independent living. Vaccines, antibiotics, surgery, and silver nitrate drops for newborns have eradicated most of those causes of blindness.

In the 1940s, high oxygen levels used in early hospital incubators actually caused blindness, a condition then called retrolental fibroplasia (RLF). From 1940 to the mid-1950s, nearly 13,000 infants were blinded this way, dramatically increasing the blind population. Educators had only a few years to prepare before these children were ready for school.

For the first time, Perkins was unable to admit all applicants. Enrollment went from the low 200s to more than 300. In 1952, director Edward Waterhouse drew up the New England Plan, offering five state governments help with training teachers, screening and placing blind children, and providing braille materials and many other services to teachers and students on an actual-cost basis. The plan inaugurated the private-public collaboration to provide special education that continues today.

In the early 1950s, Perkins took the role of accepting blind students with the most academic aptitude. The school grew into a respected preparatory school serving primarily students with a single disability and preparing them to become independent adults. The Perkins vocational workshop in South Boston was closed in 1952. More than half of Perkins high school graduates during this period went on to further education.

Then, in the 1960s, the maternal rubella epidemic created another spike in the blind population. Many of these babies also had hearing loss and other disabilities. The school's deafblind population increased from 10 or fewer before 1950 to nearly 90 in 1974, almost a third of total enrollment.

Today, the country's leading cause of childhood blindness is prematurity, a condition now called retinopathy of prematurity, as doctors have learned how to save babies at ever-lower birthweights. The more premature the infants, the more disabilities they are likely to have—deafness, mental retardation, cerebral palsy, low muscle tone, poorly developed respiratory and digestive systems, and so on. In recent decades, an increasing proportion of Perkins students have multiple disabilities. In 1982, Perkins changed its charter to allow the school to serve persons with disabilities other than blindness.

At the same time the makeup of the blind population was changing, new legislation changed *how* blind and other disabled children are educated.

State and federal laws required public schools to develop special-education programs to include all children. Towns were required to explore all possible options before placing children in private schools. Massachusetts was the first state, in 1974, to pass the new educational reform, called Chapter 766.

Similar reforms passed by states across the country, and the federal government in 1975, deeply affected every school—but especially schools that served only students with disabilities, such as Perkins. Many parents preferred to keep their children at home once public schools became an option. Only the most severely impaired children were referred to private schools, adding to the swift trend already begun by medical advances.

The biggest time of change came just as Benjamin F. Smith became Perkins's sixth director in 1971. Smith was the school's first director who was visually impaired and the first to have graduated from the Perkins teacher-training course. The road ahead was clear. Perkins would have to rise to a new challenge: to educate and care for children with multiple disabilities, whose right to an education was, for the first time, legally guaranteed.

Smith emphasized that the school's philosophy would remain the same: "Perkins has always aimed at preparing our pupils for life," he wrote. "Skills or aptitudes that we [formerly] could leave our pupils to develop for themselves, with the help of their families or future employers, now need to be made part of the curriculum. . . . [T]his experience will mean for them the difference between life in a community rather than in an institution."

More students were accepted on an ungraded basis, to work toward a certificate of accomplishment rather than a high-school diploma. Vocational training—in photography, small-engine repair, wood and metal work, graphics, mechanical drawing, switchboard, sales, retail, food service, child care, and in recent years, computers—was emphasized again for all students.

In the 1970s and 1980s, programs for Perkins students with multiple disabilities focused on their cottages, where they were taught regular classes as well as life skills, such as personal hygiene, food purchasing and preparation, housekeeping, and social skills. Off-campus apartments and community residences gave approximately 30 Perkins graduates the opportunity to use the skills they had gained and to learn new independent living skills.

By the late 1970s, federal scholarship money had created a crop of teachers schooled in new specialties offered at universities: education of the deaf, blind, deafblind, developmentally disabled, learning disabled, physically disabled, and orientation and mobility. These new teachers—many of whom are still with the school—soon infused Perkins with new energy and expertise.

In the late 1990s, the pendulum began to swing again. Some parents and other advocates have successfully argued with state and town governments that their children are better served in private residential schools. Some public schools have found that high-quality special-education services for students who are blind are more expensive and difficult to provide than first thought.

In recent years, almost half of Perkins Secondary students have transferred from outside schools, rather than coming from the Lower School. Perkins, which has always been certified to offer high school diplomas, is again adding more academic courses to its curriculum. In the next 20 years, the number of people who are blind is expected to double, due to longer life spans and increased survival rates of premature babies. Perkins plans to continue evolving in order to meet their needs.

BENJAMIN F. SMITH, PERKINS'S SIXTH DIRECTOR, 1971–1977. Smith presided over a period of great change at Perkins. Since the special-education reforms of the 1970s, most students with disabilities are taught in inclusive classes at their local public schools. Those who come to residential schools such as Perkins often have multiple disabilities that require individualized instruction in career education and independent living skills. Under Smith's leadership, the Perkins staff acquired new professional skills and adapted to the challenges.

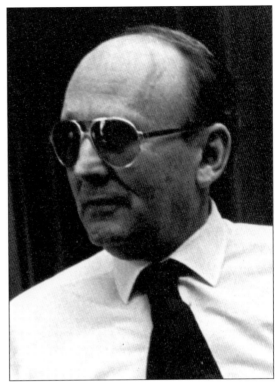

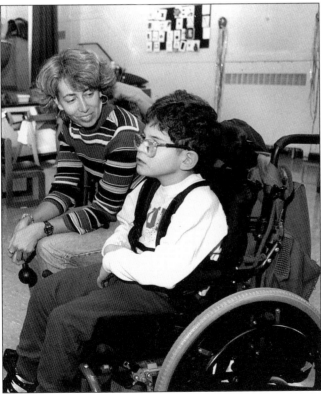

NEW NEEDS, NEW CHALLENGES. In the 1970s, the educational needs of the Perkins student body demanded new training and new thinking. Renovating the campus from the ground up, the school's staff made the transition with commitment to the service that is the Perkins legacy.

111

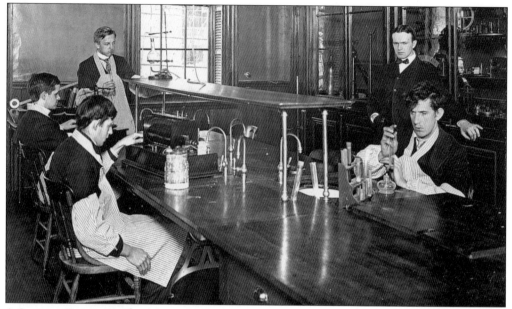

A SCIENCE CLASS, 1904. Although instruction techniques at Perkins have evolved greatly over the decades, the school's commitment to providing its students with the best instructional materials is unchanging. These young men are conducting chemistry class projects with well-maintained, up-to-date equipment.

CURRENT TECHNOLOGY. Computers have profoundly changed the learning process for students who are blind. Software programs have introduced fun to subjects like arithmetic, and word processing and electronic communication have made writing and expressing oneself much easier. Adaptive technologies can convert a Web page or printed text to speech, large print, or braille, giving people who are blind access to new worlds of information.

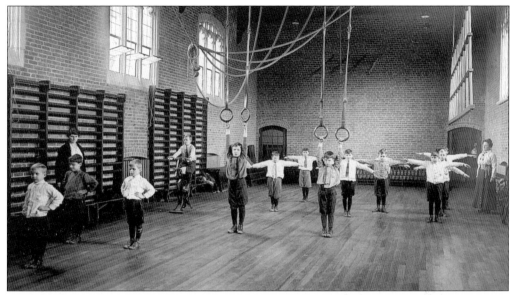

A Lower School Physical Education Class, c. 1915. Most of the boys in this photograph are performing calisthenics. One is riding a stationary bicycle, and two are preparing to soar on trapeze rings.

Goalball. The Perkins Towerhawks are ferocious goalball competitors. A team scores by rolling a ball past its opponent's goal line. The ball has bells inside, and players track its position by listening. All wear eye covers so that no one has a visual advantage. Goalball was invented in Europe in 1946 to assist in the rehabilitation of blinded war veterans. Its popularity has spread around the world since it was introduced at the 1976 Paralympics in Canada.

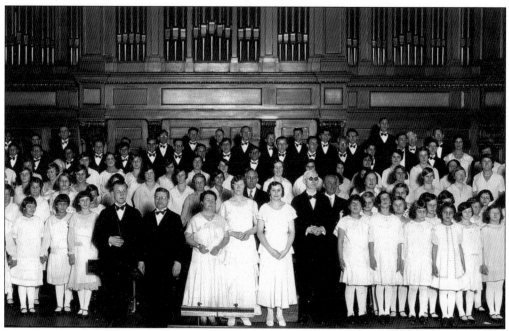

A PUBLIC CONCERT, THE 1920s. Members of the Perkins chorus, ranging in age from about 8 to 19, perform at Jordan Hall, in front of the huge pipe organ.

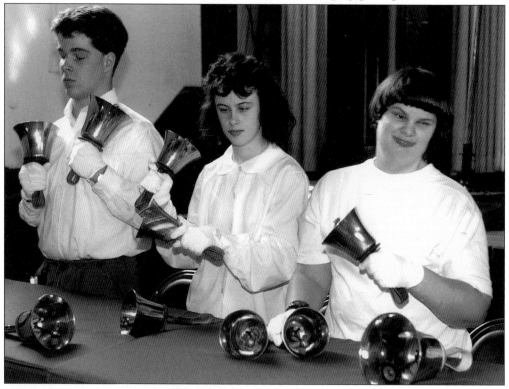

THE PERKINS HANDBELL ENSEMBLE. A lively part of holiday concerts for years, the handbell ensemble also regularly performs in regional festivals.

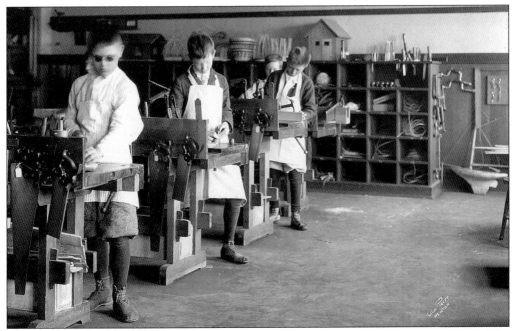

WORKBENCHES, 1923. In the background are neatly organized tools and examples of the students' handiwork: some handsome dollhouses and a jaunty toy sailboat. Teaching practical as well as academic skills is one of Perkins's foundation principles. (Lila Perry photograph.)

SKILLS FOR INDEPENDENCE. This dedicated classroom volunteer is using hand-on-hand guidance to teach a young girl how to prepare a nutritious snack. Daily living skills that will help students live as independently as possible are a vital part of today's curriculum.

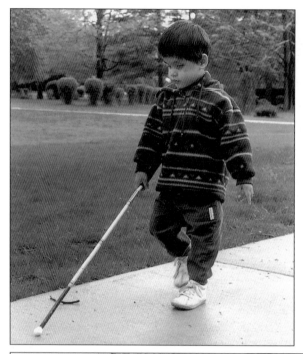

ON THE MOVE. People who are blind learn to travel in four ways: with a cane, with a guide animal, with a sighted human guide, and by tracking a stationary object such as a railing, a wall, or furniture. Children are not usually ready for the speed and responsibility of a guide animal until their late teens.

KEVIN J. LESSARD, PERKINS'S EIGHTH DIRECTOR, 1985–2002. Lessard (left), who began his career at Perkins as a houseparent right after college, created the Hilton/Perkins Program, which has spread the Perkins expertise in education of children who are blind with additional disabilities or deafblind throughout the world. He also presided over the extension of services to infants, toddlers, and their families, and the challenge of welcoming large numbers of students with multiple disabilities.

OLYMPIC ATHLETE MARLA RUNYON. As the Perkins ambassador, Runyon (left) helps spread the word about the school's mission by volunteering. Legally blind herself, she is a teacher in deafblind education as well as an Olympic runner. Runyon has recently taken up long-distance running, and Perkins students and staff cheered her on as she ran the 2003 Boston Marathon.

STEVEN M. ROTHSTEIN, PRESIDENT. The ninth person to direct the school in its 175 years, Rothstein (right) assumed leadership in 2003 under the new title of president. His wide experience in government, education, social services, and nonprofit organizations serves as valuable background as he leads the complex global institution in the 21st century.

GRADUATION DAY. Graduation at Perkins is a jubilant annual event. Staff and family feel nearly as proud as the hardworking graduates and celebrate students' accomplishments with applause, cheers, and a few tears. (John Kennard photograph.)

Ten

HILTON'S LEGACY, PERKINS'S VISION

Not long after Kevin Lessard became Perkins's eighth director in 1985, he got a telephone call from Donald Hubbs, who headed a foundation begun by the late Conrad Hilton.

Hilton's life had followed a classic American success story. The eager young man rose through the ranks of his father's trading business and then built an international empire of real estate and hotels. He had always revered Helen Keller as a hero. In his teens, he had been deeply affected by Keller's book *Optimism*. He never met her, but Hilton and his dad once tried to get into a sold-out lecture by Keller—his dad got in, but he did not. That very day, the young Hilton decided to drop out of military academy and start in business. "[H]ere was a girl barely eight years older than I," Hilton wrote in his autobiography *Be My Guest*, "calling out from a different world, a world that filled me with dread, and insisting that I personally must recognize pessimism as a sin. . . . I thought she was great. I still do!"

Hilton's will instructed his foundation "to relieve the suffering, the distressed, and the destitute" and to aid schools, hospitals, and places of worship that "shelter little children . . . as they must bear the burdens of our mistakes."

Hubbs thought of Perkins, a pioneer in deafblind education and one of the schools Keller had attended. He stressed, however, that his call to Lessard was purely informational. Hilton's estate had been tied up in court for six years already. No one knew when, how much, or even whether money might become available.

Lessard thought little more about the call. Perkins was just completing the transition to serving more students with multiple disabilities. Administrators had time again to think about new dreams for the school. One dream was to systematically extend the Perkins expertise in education to people who are deafblind or multiply disabled to Asia, Africa, Latin America, and Eastern Europe. Those regions had most of the world's disabled population but offered little, if any, education or services for children with disabilities. Most of the services that existed were for children with single disabilities only.

Six months after his first call to Perkins, Donald Hubbs called again. Still, no funding was available, but Lessard traveled to California to meet him. Hubbs later visited Perkins and fell in love with the school, as did Hilton's sons, Barron and Eric, a bit later. Lessard and Hubbs kept in close touch over the next few years.

Then, in 1988, the California attorney general released to the Conrad N. Hilton Foundation its share of the estate. Hubbs called Lessard back for a meeting. Again, Lessard laid out the Perkins priorities: early intervention, teacher training, parent

organizations, and curriculum and material development—both in this country and overseas. The price tag: $15.4 million over five years. Hubbs calmly responded, "That's fine."

Lessard was stunned. So was the Perkins board. At the time the largest grants the school had ever received from a private foundation were in the neighborhood of $150,000. Its annual budget was $20 million. The challenge was to use the new money well—without losing the school's traditional character and mission.

The Hilton funding catapulted the school's reach around the globe. First, Perkins contacted its teacher-training alumni and colleagues in Argentina, Thailand, India, Brazil, Kenya, and South Africa to find out what needs they saw. The strategy ever since has been to find trustworthy local partners with experience serving children with disabilities and then to help them develop their programs or start new ones, one country at a time.

The Hilton/Perkins Program, which now works with partners in more than 50 developing countries, rarely provides direct services, buildings, or staff. Rather, it helps launch schools and programs by offering training, grants, networking, consulting, fund-raising assistance, and materials. Hilton/Perkins staff members in Watertown and around the world work closely with administrators, teachers, parents, and students in developing countries, with a clear goal for each project to become independently funded and locally run.

The 2004 numbers show how dramatically the Hilton/Perkins Program has expanded services for children who are deafblind or multiply disabled in developing countries:

> Almost 8,000 children are served by 125 programs in 225 schools or communities in 50 developing countries, compared with 250 children in 9 programs in 11 countries before 1989.
>
> Some 2,400 professionals in developing countries are trained each year by 100 educators, and 17 universities worldwide now have teacher training programs or coursework on serving children with multiple disabilities.
>
> Twenty-five countries have active parent support groups that help and train families of multiply disabled children.
>
> Books, textbooks, articles, and fact sheets for teachers and parents have been published in 19 languages.
>
> In the United States, the Hilton/Perkins Program has helped start 11 programs for infants and toddlers, focusing on inner city, rural, Spanish-speaking, and Native American families. It has also helped expand master's programs in multiply disabled education in seven U.S. universities.

Donald Hubbs, now in his eighties, has relished his late-in-life role as an independent thinker in the grant-giving world. The Perkins Preschool in the Northeast Building is now called the Donald H. Hubbs Children's Center. The Deafblind Program is now housed in the Conrad N. Hilton Building, dedicated at a 1994 ceremony at which former president George H. W. Bush spoke.

Rather than using the foundation's resources to screen yearly proposals renewing small grants, Hubbs believes in identifying a few major projects, selecting organizations to implement them, and then setting up financial vehicles that will fund them in perpetuity. That philosophy has tremendously invigorated the foundation's beneficiaries, such as Perkins. To date, the Conrad N. Hilton Foundation has given the school $62 million in grants and loans. The foundation's commitment to Perkins will help sustain its international work long into the future.

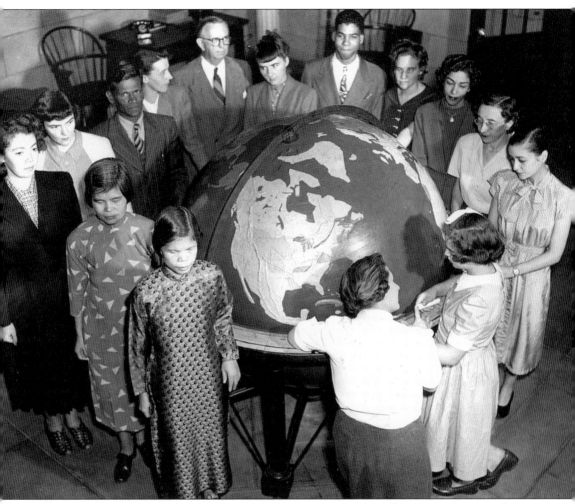

AN INTERNATIONAL GATHERING, 1950. Perkins international staff and students gather around the enormous tactile globe in the Howe Building lobby. The school has always had an international outlook. The founders drew inspiration and recruited teachers from European schools. The Greek-born second director, Michael Anagnos, started the library and museum in cooperation with the Vienna School for the Blind. Perkins teacher Francis Campbell participated in founding the Royal National College for the Blind in England.

TEACHER TRAINEES, 1958. In the past 60 years, Perkins programs have trained nearly 400 foreign teachers, including many who were themselves blind. This international commitment continues through the work of the Educational Leadership Program, sponsored by the Hilton/Perkins Program. Educators come from countries with few services for students who are deafblind or multiply disabled, and spend an academic year learning how to implement these services and train other teachers in their home countries.

TEACHER TRAINEES, 1926. Perkins established its teacher training program, the first in the country, in partnership with Harvard College in 1920. Trainees studied educational theory during the first semester and classroom techniques during the second. The program drew participants from around the world.

EDWARD J. WATERHOUSE, PERKINS'S SIXTH DIRECTOR, 1951–1971. Waterhouse (second from the right) is shown here participating in a 1966 conference of educators of the blind in New Delhi, India. He was a leader in the field of deafblind education and international education of the blind. He brought Perkins to international prominence and was instrumental in the production and distribution of the Perkins Brailler. Waterhouse remained active in the field long after his retirement.

A STUDENT QUILT. Even the youngest students participate in Perkins's international commitment. Every other year, Lower School students create and raffle a quilt to raise funds for a school for children who are blind in another country. The students choose the recipient school. Over the years, they have given the money to schools on every continent in the world.

A Greek School for the Blind, the 1980s. Surrounded by students, former director Kevin Lessard is visiting an Athens school. The school's first director, Samuel Gridley Howe, fought for Greek independence in the 1820s; the second director, Michael Anagnos, was Greek; and Perkins has always retained special affection for the country. In 1981, the Perkins Scout troop traveled to Greece and visited many sites significant in Perkins's history.

Training Volunteers in Colombia. This volunteer is enjoying a tactile game with a student who is deafblind. This Medellin-based program serves children throughout Colombia. Projects supported by the Hilton/Perkins Program teach communication techniques and multisensory exercises to parents and teachers of children who are deafblind or multiply disabled.

A LESSON IN RUSSIA. The Deafblind Children's Home in Sergiev Posad now serves about 140 children. Many countries offer education for children who are blind but have few resources for students who are deafblind. The Hilton/Perkins Program helps teachers of the visually impaired learn how to expand services and reach children who are deafblind or multiply disabled.

A BELIZE CLASSROOM. Hilton/Perkins consultants frequently travel all over the world to keep in touch with teachers of the deafblind. The consultants bring training, advice, and encouragement, and are rewarded by getting to meet the children who benefit from the program's work.

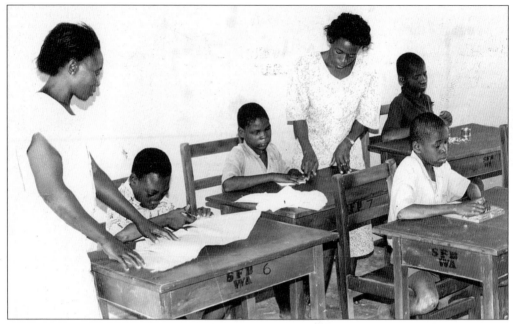

A Braille Lesson at the Wa School in Ghana. Most teachers of children who are deafblind or blind with multiple disabilities in developing countries have received training from a Perkins program.

Family Support. The Helen Keller Institute for Deaf and Deafblind in Navi Mumbai was the first to provide education for families with children who are deafblind in India. Learning sign language and other communication techniques is vital for family members to build strong relationships. The Hilton/Perkins Program sponsored this 1999 workshop in India on the needs of siblings.

WORKING AND PLAYING TOGETHER. This teacher of children who are deafblind shares a moment of jubilation with her teenage students at a family workshop sponsored by the Hilton/Perkins Program in Navi Mumbai, India, in 1999.

BIBLIOGRAPHY

This is a partial listing of the sources used to create this history. For more information, please contact the Research Library at (617) 972-7250 or e-mail at hayeslibrary@perkins.org. Visit the Perkins School for the Blind Web site at www.perkins.org.

Collins, M. T., and A. Zambone. "Education of Children and Youth Who are Deafblind," *International Encyclopedia of Education* (on deafblindness), 1992.

Denenberg, B. *Mirror, Mirror on the Wall: The Diary of Bess Brennan.* New York: Scholastic, 2000.

Fradin, D. *Louis Braille: The Blind Boy Who Wanted to Read.* Parsippany, New Jersey: Silver Press, 1997.

Freeberg, E. *Laura Bridgman: First Deaf and Blind Person to Learn Language.* Cambridge, Massachusetts: Harvard University Press, 2001.

Gitter, E. *The Imprisoned Guest: Samuel Howe and Laura Bridgman, the Original Deafblind Girl.* New York: Farrar, Strauss and Giroux, 2001.

Hayden, R. R. *Erma at Perkins.* Boston: Chapman & Grimes, 1944.

Herrmann, D. *Helen Keller: A Life.* New York: Alfred A. Knopf, 1998.

Irwin, R. B. *As I Saw It.* New York: American Foundation for the Blind, 1955.

Keller, H. *The Story of My Life: The Restored Classic 1903–2003.* New York: W. W. Norton & Company, 2003.

Koestler, F. A. *The Unseen Minority.* New York: David McKay Company, 1976.

Kondellas, B. *The Educational Philosophy of Michael Anagnostopoulos, 1837–1906: Reflections on Universal Education.* Unpublished dissertation, 2001.

Meltzer, M. *A Light in the Dark: The Life of Samuel Gridley Howe.* New York: Thomas Y. Crowell Company, 1964.

The National Society for the Prevention of Blindness. *Estimated Statistics on Blindness and Vision Problems.* New York, 1966.

Ozick, C. "What Helen Keller Saw: The Making of a Writer." *The New Yorker,* June 16 and 23, 2003.

Silverstone, B., et al, eds. *The Lighthouse Handbook on Vision Impairment and Vision Rehabilitation.* New York: Oxford University Press, 2000.

Smithdas, R. J. *Life at My Fingertips.* Garden City, New York: Doubleday & Company, 1958.

Stenquist, G. *The Story of Leonard Dowdy: Deafblindness Acquired in Infancy.* Watertown, Massachusetts: Perkins School for the Blind, 1974.

Stuckey, K. A. "Nearly Two Hundred Years of the European Influence on the Education of the Blind in America: Howe Were These Connections Made?" Conference paper, 1996.

Walker, L. A. "To Reach the Unreachable Child." *Life,* October 1990, 88–94, 98.

Wilkie, K. E., and E. R. Moseley. *Teacher of the Blind: Samuel Gridley Howe.* New York: J. Messner, 1965.